Material Matters

"Material Matters"

THE CONSERVATION OF MODERN SCULPTURE

edited by

Jackie Heuman

Tate Gallery Publishing

Material matters

FRONT COVER Naum Gabo, *Linear Construction No.2* 1970–1 (fig.105)
BACK COVER Edgar Degas, *Little Dancer Aged Fourteen* 1880–1,
cast *c.*1922, head; left profile and x-radiography (figs.9 and 10)
FRONTISPIECE Matthew Barney working with tapioca
and epoxy resin (fig.104)

Published by order of the Trustees of the Tate Gallery
by Tate Gallery Publishing Ltd
Millbank, London SW1P 4RG
Copyright © Tate Gallery 1999

A catalogue record for this book is available
from the British Library

ISBN 1 85437 2882

Designed by Harry Green

Printed in Hong Kong by
South Sea International Press

Contents

Acknowledgements

In the course of preparing this book, we have called on the expertise and goodwill of many people. These include colleagues at the Tate Gallery and other institutions, scientists, conservators, curators, artists, enthusiasts and friends, who have all given generously of their time and knowledge. We are indebted to all those who have supplied us with vital information and contributed in many ways to this book.

Firstly, thanks are due to the Tate Gallery photographers for most of the images used in the book: Dave Clarke, Andrew Dunkley, Mark Heathcote, Ken Hickey, Dave Lambert, Marcus Leith and especially Gill Selby.

We would like to thank all the scientists who analysed materials and helped interpret the results: David Thickett of the British Museum, those at the British Petroleum Research Centre, Frances Wall of the Natural History Museum, Dr Tom Learner and Dr Joyce Townsend of the Tate Gallery, Graham Martin and Nicholas Umney from the Victoria and Albert Museum.

The following people contributed in various ways and on behalf of the other authors who feature in this book, we would like to offer our grateful thanks to Liz Alsop, Matthew Barney, Jennifer Booth and her staff in the Tate Gallery Archive, Sir Alan Bowness, Henry Buckly, Judith Collins, Conrad Duncan, Brian Durrans, Mrs L. Fairchild, John Farnham, Jim France, Matthew Gale, Michael Gaskin, Antony Gormley, Jim Grundy and his team in the Tate Gallery Art Handling Department, John Habicht, Gary Hill, Hornton Quarry, Gabo Trust for Sculpture Conservation, Allen Jones, Liz Kay, Richard Kendall, Susan Lawrie, Tom Learner, Jehannine Mauduech, Bernard Meadows, Henry Moore Foundation, Paul Moorhouse, Jennifer Mundy, Charles Penellis, Kira Perov, Roy Perry, Sean Rainbird, Ted Rhodes, Paul Robbins, Nicholas Skeaping, Chris Stephens, Joyce Townsend, David Vallance, Bill Viola, Stella Willcocks, Martin Williams, Nina and Graham Williams, Neil Wressell.

JACKIE HEUMAN

Introduction

Jackie Heuman

Since the mid-nineteenth century, sculptors have played a leading role in successive redefinitions of contemporary art. With the displacement of representational by non-representational forms of 'modern art' – a movement with sculpture in the vanguard – has come a renewed interest in the varied and often challenging materials which sculptors use. These media constitute an obvious meeting-point between artistic intention, conservation and art historical practice.

The Tate Gallery's Conservation Department aims to preserve for posterity the artworks in the Tate collection. Although much has been written on the conservation of modern art for non-specialists, the focus has been far more on paintings than on sculpture.[1] Research into materials and production methods plays an increasingly important role in sculpture conservation. Examination of the Tate's sculptures yields information about artists' techniques and materials, which not only helps inform decisions about care and conservation treatment, but can also provide insights for art historians (fig.1). Scholars now take a keen interest in art as a process, looking carefully at intentions and production techniques, as well as the finished work itself.

The methods used for restoring and conserving sculpture are normally carried out behind closed doors and may therefore seem overly arcane. The purpose of this book is to describe and explain some common conservation practices in accessible language. A glossary defines the more technical terms (see pages 00–00). To the same end, the focus will be on a detailed examination of particular works, rather than a more general explanation of the history of materials and the origins of sculptural techniques.

Yet, a brief mention of changing attitudes toward the

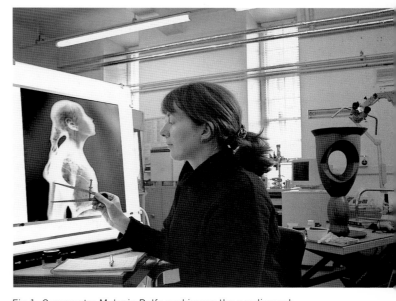

Fig.1 Conservator Melanie Rolfe working on the x-radiograph of the *Little Dancer Aged Fourteen* (1880–1, cast *c*.1922) in the sculpture conservation studio. Brancusi's *Fish* (1926) can be seen in the background

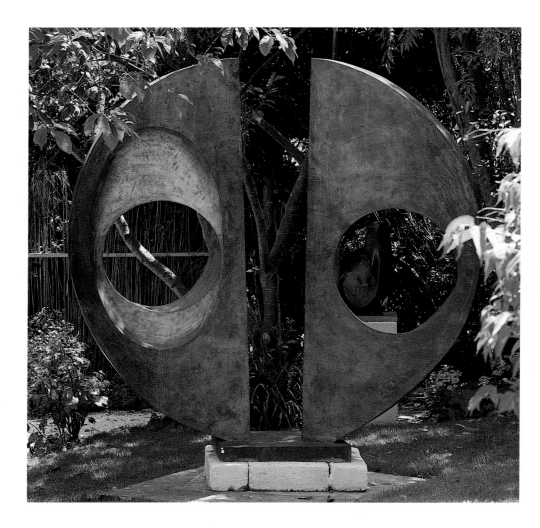

Fig.2 Barbara Hepworth,
Two Forms (Divided Circle)
(1969). Undated photograph
showing the gold interior

preservation of sculptures would help put current practice into perspective. Although fragments of antique sculpture have long been familiar in Western museum collections, the actual display of fragments has not always been acceptable. Incomplete Greek and Roman sculptures in Renaissance collections were usually restored to make them look whole and perfect. 'Antiquities thus restored certainly possess much more grace than those mutilated trunks, members without hands, or figures defective.'[2] Throughout the eighteenth century restored statues were much more highly valued than fragmented ones.

The story of the Parthenon ('Elgin') marbles illustrates the revolution in taste that occurred in the early nineteenth century. When negotiating for the Acropolis sculptures, Lord Elgin assumed that they would be sent to Rome for restoration, but Carnova and Flaxman, both renowned sculptors, felt it inappropriate to try to restore the missing

parts. After 1814, Elgin was persuaded to leave the statues unrestored.[3] This shift in the appreciation of fragmented classical sculptures has had a long-lasting effect on present-day conservation practice.

The key difference between restoring ancient works and modern sculptures is that no one knows what an ancient artefact looked like when first made. Also, if the original surface is tampered with, valuable information about the history of the work may be lost, and this is often complemented by a positive appreciation of its antique appearance. The ethical considerations that constrain the choice of treatment for restoring antiquities are therefore very different from those applied to sculptures made by contemporary artists. Conservators restoring older works often take a more restrained, minimally interventionist approach. When working on more modern works, the conservator focuses not so much on the passage of time

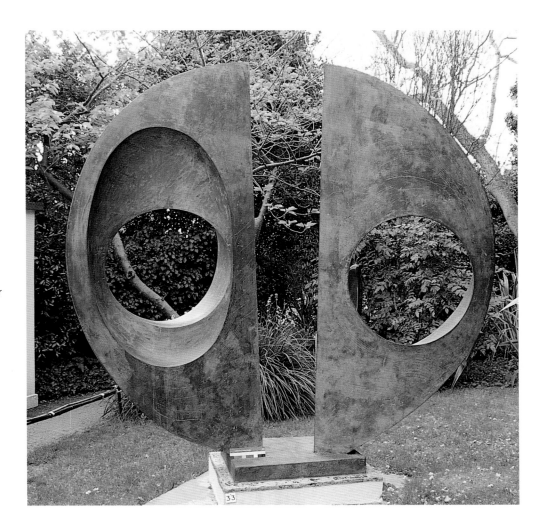

Fig.3 Barbara Hepworth, *Two Forms (Divided Circle)* (1969). Recent photograph illustrating how the gold interior has changed to a brown colour

but on the ideas and techniques which the artist used to create the work.

The sculptures considered in this volume are presented in chronological order and the chapters have been written by members of the Conservation Department's sculpture section. The works span three periods: the nineteenth, the early twentieth and the latter half of the twentieth century. Although most nineteenth-century sculptors, such as Lord Leighton, Edward Onslow Ford and Edgar Degas, used traditional materials like bronze, stone and wood, newer materials and experimental techniques were also being introduced. Ford used an innovative combination of resin and pigment as an 'enamel' in *The Singer* (1889) (see pages 35–41); Degas combined traditional techniques with more unusual materials, such as dressing his wax figure of the *Little Dancer Aged Fourteen* (1880–1) in real clothes and a wig (see pages 15–25). These media are unexceptional today,

but when the work was displayed in 1881 many viewers and critics were shocked as much by this use of unconventional materials as by the realism of the figure.

For early twentieth-century sculptors, such as John Skeaping, Constantin Brancusi, Naum Gabo and Henry Moore, the testimony of artists' assistants may be available to supplement other historical data and technical studies. This is especially valuable in the absence of explicit instructions or evidence of intent in letters and diaries, although attempts are made to interpret less direct statements where possible. Discovering the technique that the sculptor used often calls for a forensic approach – finding clues in the material and form of the sculptures themselves as well as looking at their workshop practice by examining surviving materials and relating them to twentieth-century techniques.

Barbara Hepworth's studio in St Ives, Cornwall, has been preserved since her death in 1975 and not only gives

visitors a strong impression of her working practices, but also provides clues about how she dealt with the ageing of her work. For example, the polished gold interior of *Two Forms (Divided Circle)* (1969) (fig.2) has turned brown (fig.3) while on display in the Hepworth garden, losing the original dramatic contrast between the inner gold and the outer green/brown patination. The problem facing the conservator is whether and how to restore the interior. Although Hepworth was very articulate about her ideas of contrast-

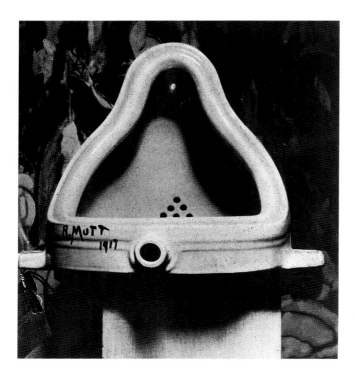

ing colour on her sculptures - 'I have often used colour within forms, and concavities, to create another dimension of light and depth which would give a contrapuntal emphasis'[4] - she did not express her attitude to the ageing of her work so clearly. However, traces of lacquer on the gold surface of *Two Forms (Divided Circle)*, together with a jar of matching yellow lacquer found in her studio, suggest that she meant to retain the shine on the inner surfaces even after weathering out of doors.

Whatever the material, interpreting the artist's intention remains an essential guide to the conservation approach. However, even evidence derived from the artist's own testimony is open to interpretation. One can almost never be sure to have captured the artist's original ideas. A new rela-

tionship has to be established between the history of the work, its current condition and our interpretation of what the artist had in mind. If the interior of *Two Forms (Divided Circle)* were to be repatinated to resemble its original gold appearance, would this re-create the artist's intention or would the new relationship between the interior and exterior surfaces amount to a reinterpretation? Conservators' recommendations can unintentionally conflict with artists' wishes. The challenge is therefore to find a solution that preserves the sculpture without disregarding the artist's intent.

While bronze and marble continued to be the most commonly used materials in the early twentieth century, ready-made or found objects began to be introduced into modern sculpture. Artists such as Duchamp created artworks (for example *Fountain* (1917) (fig.4) by redefining conceptual boundaries rather than by sculpting form. The artist's concept therefore became as important for the conservator to consider as the composition of the sculpture itself. As new concepts proliferated and new materials became more widely used, many sculptors incorporated unstable substances. Joseph Beuys and other artists chose materials to convey ideas about impermanence and decay. Beuys used margarine, wood and cardboard in his construction *Fat Battery* (1963) (fig.5). When he saw the work twenty years later he was 'very pleased with the way it was changing'.[5]

However, artists who use modern materials are not only or even necessarily concerned with ideas of impermanence. Antony Gormley felt that it was important to retain the original fruits and vegetables used in his work *Natural Selection* (1981) even though they are concealed in lead casings (see pages 82–9). Other artists have tried to extend the life of ephemeral materials by mixing them with more stable ones. Matthew Barney has done just this in his installation work *OTTOshaft* (1992) by mixing tapioca with epoxy resin (see pages 90–9). It is difficult enough to decide how to preserve tapioca or fruit, but deciding whether these works should be preserved at all becomes an ethical as well as aesthetic problem once the artist's own intentions are taken into account. The unique opportunity exists to discuss such problems with the artists while they are still alive, and a special effort is made to record the artist's views on acquisition of an artwork. With the artist's input, we sometimes adopt a more radical form of treatment than might

be applied to much older works. The practical and ethical aspects of these problems are a recurrent theme of this book.

All sculptures begin to change from the moment the artist has finished working on them. The conservator tries to retard this process but change is of course inevitable. Natural ageing and the physical impact of light, temperature, humidity and handling all take their toll. Much conservation work is routine and often unnoticed, but preventative attention, such as controlling environmental

struction in order to preserve it. Cleaning is one of the most common treatments given to the artworks in our collection. As a sculpture ages, its earlier appearance often gets forgotten. Once its existing condition has become familiar, a sculpture can have an unsettling, even shocking effect if it is cleaned. The experience and expectations of the audience will always be influenced by current treads. Deciding whether or how a sculpture is to be cleaned depends on the nature of the work, its past history and the results of a tech-

OPPOSITE Fig.4 Marcel Duchamp, *Fountain* (1917) (no longer extant)

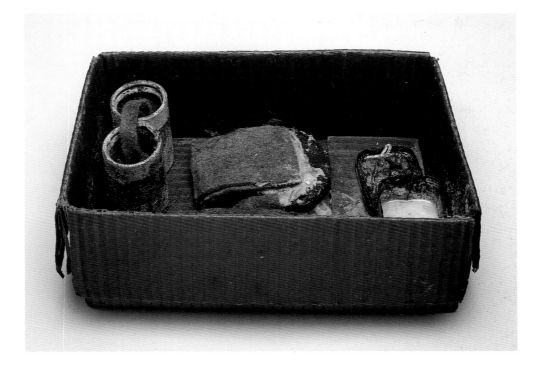

RIGHT Fig.5 Joseph Beuys, *Fat Battery* (1963)

conditions, is nonetheless essential in minimising deterioration. The condition of an artwork is also linked to its art historical interpretation as monitoring changes in a sculpture can help the art historian to judge what it first looked like. Some of Naum Gabo's works in plastic from the 1930s were made of transparent cellulose acetate that has discoloured and distorted with age. It is important for understanding Gabo's original concepts to appreciate that these plastics were once completely clear (see pages 100–7).

As the case-studies in this book illustrate, despite preventative measures a sculpture may be at risk from structural failure, inherently unstable materials, weathering, vandalism, inappropriate restorations or accidental damage. A sculpture may require anything from cleaning to recon-

nical investigation. On examination of Degas's *Little Dancer Aged Fourteen*, it was found that, far from being dirty, the surface had been deliberately darkened with pigments. This information was not only crucial to the conservator but also provided important new evidence for the art historian (see pages 14–25).

Displaying a sculpture outdoors accelerates deterioration. It may be surprising that some awe-inspiring sculptures, weighing a ton or more, are nevertheless vulnerable to the elements, more so now than ever before. The most insidious threat to outdoor sculpture is the relatively modern one of air pollution. Lord Leighton's sculpture *The Sluggard* (1885) developed corrosion while on display in the garden of Leighton House (fig.6), and only when the

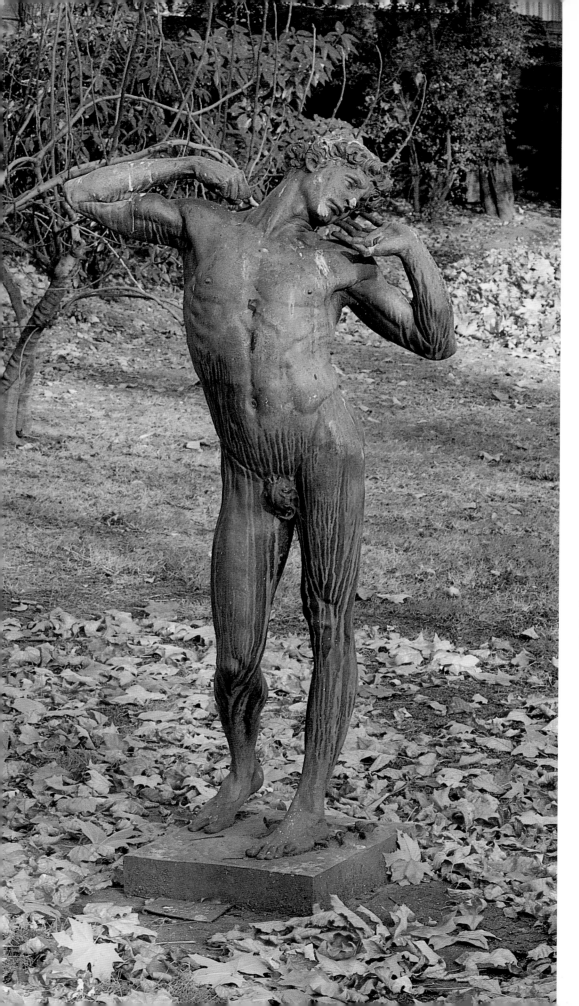

LEFT Fig.6 Lord Leighton's
The Sluggard (1885) on display
at Leighton House

OPPOSITE Fig.7 Naum Gabo
with his sculpture *Head No.2*
(1916, enlarged version 1964)

corrosion was removed was the true colour of the original patina discovered (see pages 26–33) . Skeaping's larger-than-life-size wooden *The Horse* (1933) suffered from being displayed outdoors and had to be completely dismantled to make it structurally secure (see pages 52–61). Henry Moore's *Recumbent Figure* (1938) carved from Horton stone has changed irretrievably as a result of outdoor exposure (see pages 62–71) and consequently this has subtly altered the way the work is read, understood and interpreted.

Less common, but often more damaging, is vandalism, which can result in the need for major restoration, as in the case of Allen Jones's *Chair* (1969) (see pages 72–81). The public also erodes sculptures, even if unwittingly. Who can blame those who want to touch Brancusi's beautifully hand-polished bronze *Fish* (1926) (see pages 42–51)? What is not realised is that the cumulative impact of thousands of fingers can rub away the artist's finish. Part of the conservator's role is therefore to ensure that these vulnerable tactile works are suitably protected when on display.

Conservators spend much time trying to remove or improve previous restorations, as discussed in the Brancusi, Ford and Moore chapters. These treatments may reveal more about the tastes and sensibilities of the time in which the restorations were done than about the artists' original intentions. In the past, restoration was less controlled and the aim was often to make the sculpture look 'newer' with whatever materials were available. Today, conservation materials are researched for their permanence and compatibility, and where possible all procedures affect the object as little as possible, are documented and made reversible. This will allow a future conservator to remove all aspects of the restoration without damaging the original material.

The emergence of technology in the art world represents a further challenge to the ingenuity of conservators. Some of the elements used in sculptures and installations such as videotape are sometimes mistakenly assumed to be very stable (see pages 108–15). As artists introduce new concepts and techniques into their work using every material imaginable, contemporary taste and values are being altered. Technology and material science have already changed the relationship between artists' and audiences' expectations of the ageing of sculptures. Rusted sculptures have usually been thought unappealing but this is becoming an outdated response with the introduction of Cor-ten, a steel alloy that was developed to provide a stabilised rusted surface on outdoor exposure and used on such artworks as Naum Gabo's *Head No.2* (fig.7).

Sculptures are becoming increasingly complex in structure and in the variety of media used and we do not

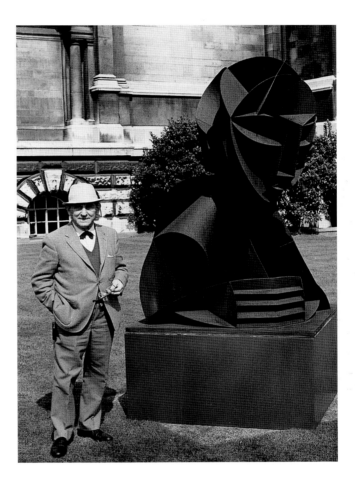

yet have adequate solutions to slow down the degradation of many modern materials, particularly plastics. Many of the case-studies that follow discuss materials that have only been identified through analysis. Continuing scientific research will provide a clearer understanding of the effects and causes of deterioration and should help us find better solutions to complex problems. Conservation is still a relatively new discipline and is continually evolving. This book aims to offer insights into the current state of a branch of conservation in which the dynamic interaction between principle and practice, materials, techniques and ideas is paramount.

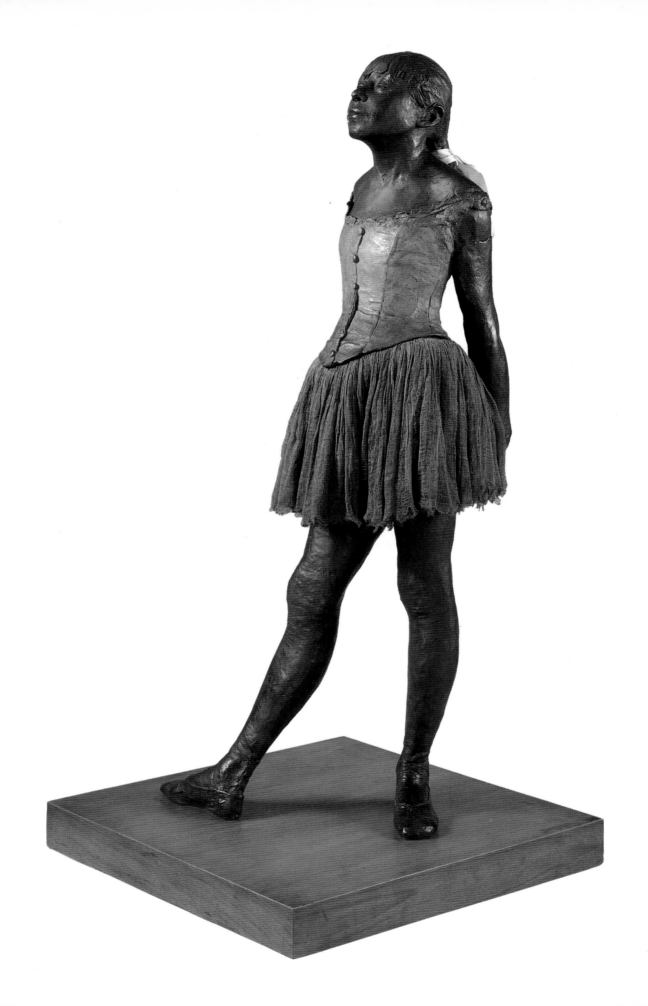

Little Dancer Aged Fourteen
1880–1, cast *c*.1922

EDGAR DEGAS (1834–1917)

Melanie Rolfe

The *Little Dancer Aged Fourteen* was the only one of Degas's sculptures to be shown in public during his lifetime, although he was probably making sculpture from about 1865 and continued to do so until his death. It was displayed, in a glass case, at the sixth Impressionist Exhibition in 1881. The model for the original was a young student at the Paris Opera Ballet School, Marie Van Goethem, who celebrated her fourteenth birthday in June 1879.[1] The realism of the figure and the use of unconventional materials shocked critics. The sculpture was modelled in a reddish brown wax, the warmth and translucency of which, if not its actual colour, would have suggested flesh. Her clothes – the bodice, tutu, stockings, ballet shoes and ribbon – were real, not modelled, and she had real hair. Her un-idealised features and stance led to reviews describing her as a guttersnipe, an 'opera rat', the 'ideal of ugliness'. However, some critics anticipated her future appeal, including Huysmans who called the piece 'the only really modern attempt I know of in sculpture'.[2]

After Degas's death in 1917 a number of his sculptures were found in his studio. As they were made of wax, clay, plasticene and mixtures of these with other materials, many of them had deteriorated.[3] His friend and dealer Durand-Ruel made an inventory of his possessions and wrote: 'I found about 150 pieces … Most of them were in pieces, some almost reduced to dust. We put apart all those that we thought might be seen, which was about one hundred … Out of these thirty are about valueless; thirty badly broken up and very sketchy; the remaining thirty are

Fig.8 *Little Dancer Aged Fourteen* (1880–1, cast *c*.1922) after conservation treatment, 98.5 × 41.9 × 36.5 cm, 31 kg. N06076

quite fine.'[4] A photographic inventory was made in the studio showing fifty-three of the sculptures; it includes three views of the *Little Dancer Aged Fourteen* which appears to be intact except for a crack near the top of her left arm.

An agreement was drawn up between Degas's heirs and the Hébrard foundry in Paris to make bronze casts of the sculptures. Preparation for the casting had to wait until the end of the war and in the meantime the sculptures were stored in the cellar of the foundry. The first casts appeared in 1921. Seventy-four of the hundred mentioned by Durand-Ruel were eventually cast, some in editions of more than twenty. Although the original contract stipulated that no more than twenty-two editions of each cast should be produced (one for the heirs, one for the foundry and twenty for sale), twenty-eight casts of the *Little Dancer Aged Fourteen* are known to exist.[5] Casts of Degas's sculpture can now be found in many museums throughout the world.

For many years it was thought that the originals had been destroyed in the casting process. Then in 1954 came a sensational revelation from the foundry – sixty-nine of them, including the *Little Dancer Aged Fourteen*, were still in existence, stored in the cellar. These were all bought by the American collector Paul Mellon in 1955. Since 1991 the original of the *Little Dancer Aged Fourteen* has been on display in the National Gallery of Art, Washington.

Once the original wax and mixed media sculptures became accessible, there was much discussion as to their relationship to the better-known bronzes. Recently, conservators at the National Gallery of Art, Washington, have carried out technical investigations of some of the originals, shedding light on Degas's working practices. There have also been studies into the extent to which some of the original waxes were altered for the purposes of casting.[6] However, prior to this investigation, there has been little examination of the casts themselves to determine how they were made.

The Tate's cast of the *Little Dancer Aged Fourteen* was acquired in 1952 from Puvis de Chavannes (the son of the artist of the same name) who had married Nelly Hébrard. Her father had owned the foundry which produced the casts and she took over the business in 1932. Since its acquisition this cast has been in a glass case, on permanent display in the Tate. It was decided to carry out a detailed technical examination to ascertain its condition and as a

basis for comparison with other casts. The examination also revealed more about how the foundry approached the reproduction of the varied and subtle effects created by the different materials of the original.

The bronze is about two-thirds life size and shows the dancer tensed with her right foot forward, hands clasped behind her back and head tilted up (fig.8). It is mounted on a square wooden base into which a facsimile of the artist's signature has been burned and which also bears the founders' stamp 'CIRE | PERDUE | A. A. HEBRARD'. Like the original wax, the bronze figure wears a real fabric tutu and ribbon. The skirt is contemporary with the cast, one of those reputedly made by Degas's niece and heir Jeanne Fevre. The grosgrain texture of the original bodice fabric is visible on some areas of the bronze bodice and on close inspection the fine woven texture of the stockings can also be discerned on the legs. The bodice is a dirty cream colour and the lower part especially appears to have darkened. The skirt too looks dirty with a greenish yellow tinge. Elsewhere the surface is a glossy, rich warm brown with red and orange accents. There are darker areas on the upper surfaces: the head, shoulders and fronts of the legs.

The *Little Dancer Aged Fourteen* was the last and most important of Degas's sculptures to be cast. The skill of the Hébrards' master founder, Albino Palazzolo, was instrumental in the production of the casts. He was able to make moulds using gelatine which was flexible and could be removed from the original without harming it. Recent studies comparing the waxes and bronzes have shown that some pieces were 'made good' and tampered with at this stage.[7] This does not appear to be the case with the *Little Dancer Aged Fourteen* as the noticeable crack near the top of her left arm is reproduced in the cast.

The gelatine moulds were used to make wax casts with a core of coarse plaster, the first stage in the lost-wax method of casting. The wax cast is covered with more plaster, forming an outer shell. The wax can then be melted out and molten bronze poured into the space it occupied between the inner core and the outer shell. This process was used to produce a bronze master cast or *modèle* of each sculpture which could then be used to make subsequent moulds and casts. The *modèles* have been identified by their very slightly larger size and differences in surface

detail.[8] However, the *Little Dancer Aged Fourteen* differs from the other works in that there is no bronze master cast known but there are two plaster versions which could also have been cast from the gelatine mould and used as *modèles*. The one in the Joslyn Art Museum, Omaha, has certain characteristics of a working model, most noticeably marks on the surface where the moulds were cut away and indentations on the base to locate subsequent moulds.[9]

X-radiography was used to examine the structural condition of the Tate's cast and it also gave us more information about the casting process. Fig.9 shows the x-radiograph of the head and torso in profile, revealing many features typical of lost-wax casting. Small 'pins' visible near where the hair joins the head were originally longer, running through the wax from the inner plaster core to the outer plaster mould to ensure they kept apart while the molten metal cooled and solidified. The wires were part of the structure of the inner plaster core that was removed after casting. Plugs at the top of her head and on her shoulders and chin are remnants of the system of 'runners and risers' through which the molten metal flows.

More evidence of the finishing and cleaning of the surface which is necessary when a bronze emerges from casting can be seen in fig.11. A leaf shape at the top of the left thigh and a less obvious one on the right wrist are bronze patches inserted to fill holes left by the vents or breathing tubes. (These holes were introduced into the wax and plaster casting structure to allow the escape of gases produced during the pouring of the bronze.) Before the holes were patched they would have given some access to the interior of the cast; this explains why the surrounding areas are relatively clear of wires and other core debris. At various points on the figure the pale lines indicate a greater thickness of metal in the cast walls. Some, like the finer lines on the neck and just above the left ankle, are likely to be the result of bronze seeping into cracks in the investment core. The position of others (ankles, knees) suggests joins but there is no technical reason why the piece could not have been cast whole.

Fig.10 shows pale lines encircling the dancer's ankles together with a greater thickness of metal on the inside of both. These are reminiscent of Roman jointing, the traditional method of joining separately cast parts of a bronze

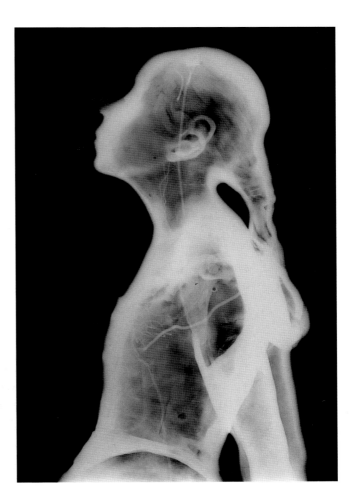

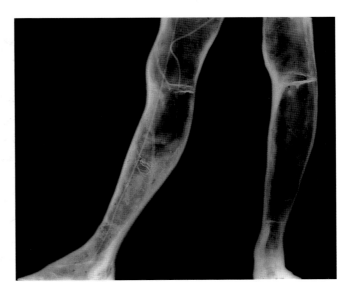

TOP Fig.9 X-radiograph of the head and torso in profile

ABOVE Fig.10 X-radiograph of the lower legs and feet, showing the weld joints at the ankles

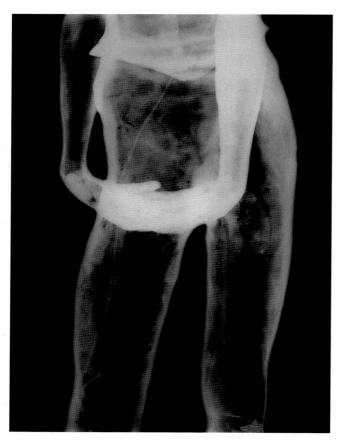

ABOVE Fig.11 X-radiograph of the upper legs and lower torso, showing the leaf-shaped patches

OPPOSITE Fig.12 Detail of the face with the brown patination showing through on the top of the head and nose and pink wax on the lips

sculpture in which the two pieces slot into one another. It is possible that if the feet suffered major defects in casting, (which is always a danger with the extremities of a piece) they might have been recast and joined on in this way. However, these images reveal no other features, such as the pin which would have been driven through the two pieces, to confirm this. The extra thickness of metal could also be intended as reinforcement of what is a weak point structurally. These features should become clearer once other casts of the *Little Dancer Aged Fourteen* are examined in this way.

The surface of this bronze is unusual in the way that it is coloured. Bronzes are usually finished by chemical patination – different mixtures of chemicals are applied, usually hot, to alter the surface of the bronze and give colours such as brown, green or black. The bronze cast of the *Little Dancer Aged Fourteen* was first given a warm brown patination. This can be seen in fig.12 showing through on the nose and the top of the head. However, further colour was then applied over the patination. This is most obvious on the cream-coloured bodice but the investigation has revealed how it extends over the whole cast.

The surface was examined closely under the microscope and tiny samples were taken for analysis of pigments and media. These indicated that both paint and various coloured waxes had been applied to the surface. A fairly limited range of commonly used pigments was found – white lead, carbon black and yellow, red and brown ochres. The purpose of this colour was to capture some of the subtlety and variation of tone and colour produced by the different materials of the original sculpture.

The examination also revealed that the sculpture was not dirty or discoloured but that some areas were darkened deliberately using pigments. When the bronzes were cast the original wax sculpture remained in the foundry where, placed side by side with the new bronze, its surface appearance could be accurately imitated. A dark-pigmented wax mixture was used to darken upper surfaces such as the shoulders and shins which appear very dark on the original. This dark wax was also applied to the hair as fig.13 illustrates. This photograph also shows clearly the golden brown wax on the lower part of the face and a splash of pink in the ear. Pink was also smudged on to her lips and around her eyes rather like make-up (fig.12). This mainly

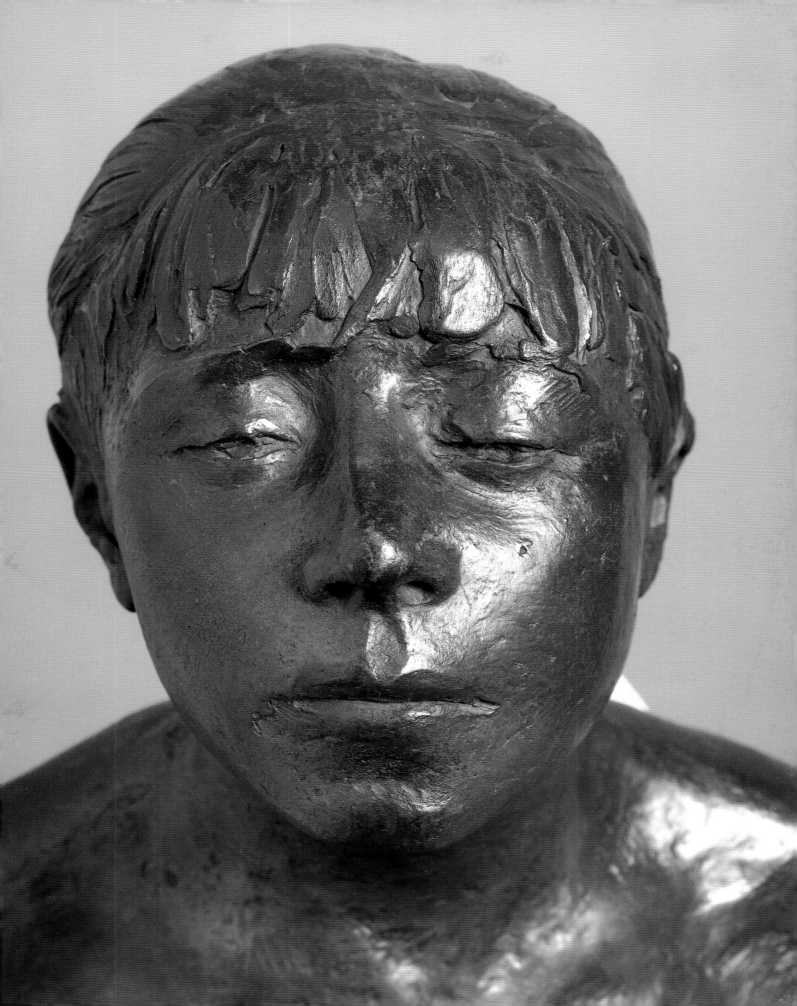

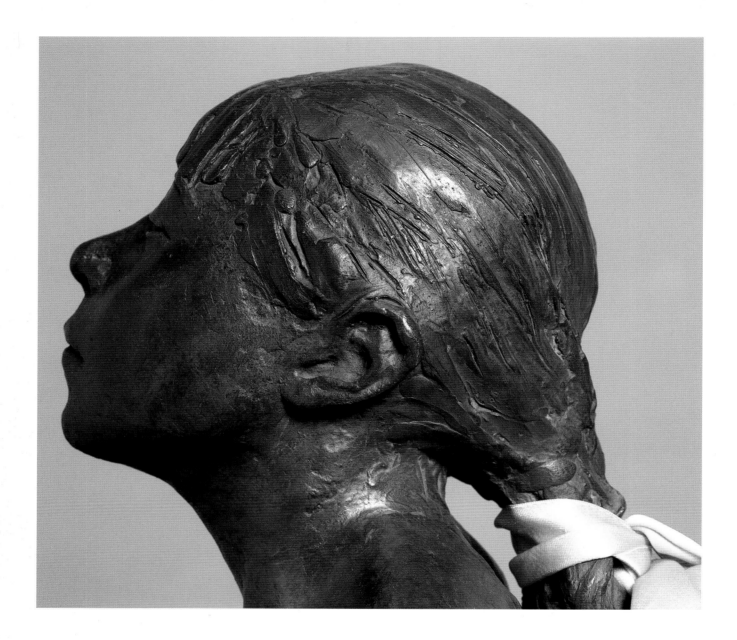

beeswax mixture, ranging in colour from pale orange to pink and brown, actually covers all of the flesh areas not covered by the much darker wax (fig.14).[10] It is applied quite freely and gives an overall impression of warmth and life rather than a precise realistic colour.

The bodice is painted with a cream-coloured oil paint applied quite thickly over a lead white oil primer. Cross-sections of samples taken from the lower part of the bodice clearly show that a darker layer was deliberately applied over the cream-coloured oil paint to darken it (fig.15). This is a pigmented wax mixture like that used elsewhere. This

Fig.13 Head, with left profile showing the dark hair and warmer flesh tones

Fig.14 Torso, right profile. The texture of the original bodice fabric can be clearly seen. A very dark wax covers the shoulder whilst warmer coloured waxes are used on the arm

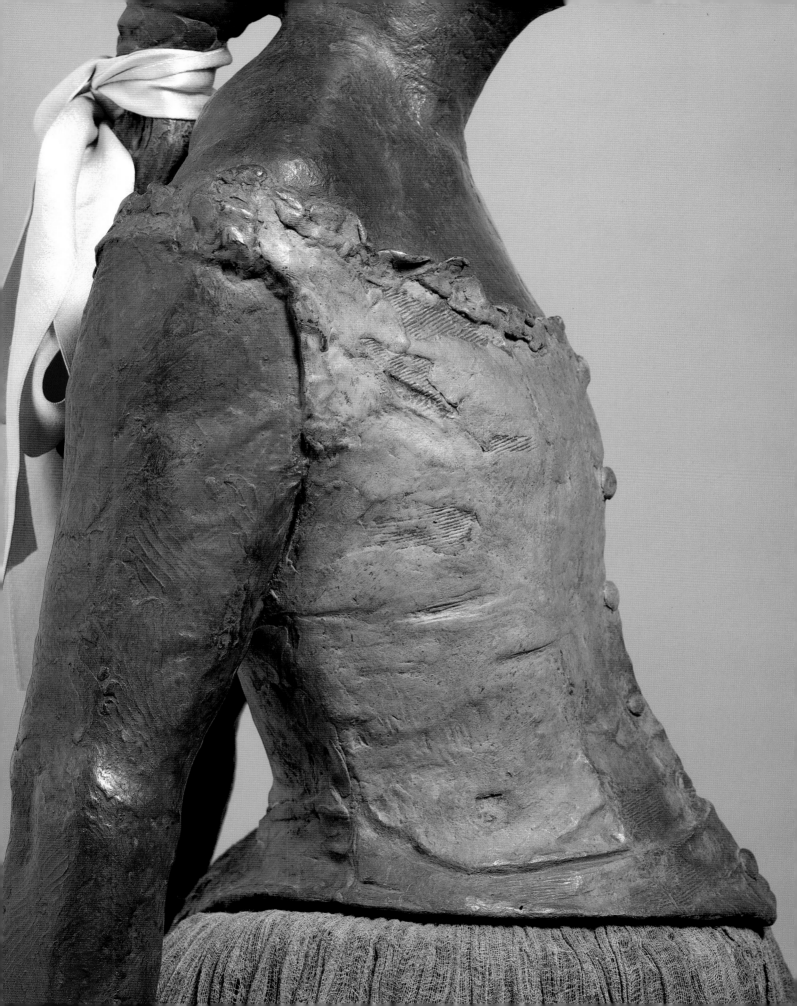

darkening of the lower bodice is also very noticeable on the original. The pink and orange beeswax mixture has also been used over the paint on the bodice (fig.16).

Since the original is available for comparison it can be seen that the darkened areas of its surface do correspond with those of the cast. So far it is not known whether these dark areas on the original of the *Little Dancer Aged Fourteen* are the result of dirt, darkening of the surface owing to age, or whether they were deliberately darkened by

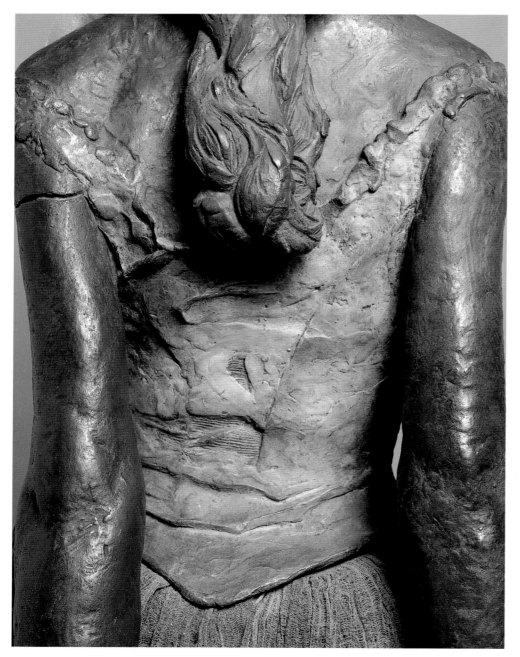

ABOVE Fig.15 Schematic drawing of cross-section through layers of applied colour on bodice
(1) Wax toning layer with fine-grained black particles and some larger particles of black pigment
(2) Oil paint with roughly evenly sized particles of lead white, red, orange/brown and yellow ochres and ivory black
(3) Lead white/oil priming

LEFT Fig.16 Back of the bodice with coloured wax applied over the cream paint

Degas.[11] It is interesting to speculate on the last possibility; if the dark areas were applied by Degas deliberately, the effect they produce is of the figure lit from below – that is by footlights, as the dancers in Degas's paintings and pastels are often shown. On the other hand, if they do turn out to be caused by dirt or ageing of the materials, the foundry's faithfulness to the original must have extended to reproducing the effects of time on the piece which was by then over forty years old.

The skirt is original to the cast. These skirts, now worn by most of the other casts, are probably very different in appearance to that of the original as displayed by Degas in 1881. The inventory photograph (fig.17) taken in 1917 just after Degas's death shows a much longer differently shaped skirt, sticking out less just below the waist and becoming fuller further down. It already looks rather uneven and deteriorated. When the moulds were made it would have had to be removed, and may have fallen apart at this time, as the original now seems to be wearing a much shorter remnant of it. Interestingly, the shorter skirts worn by the casts are much more in the fashion of the 1920s when the first casts appeared.

Some of the other casts have been given replacement skirts in a variety of colours and of a cleaner and crisper appearance. The skirt of the Tate's cast was examined and found to consist of four layers of a cotton tabby weave fabric (an open weave known commercially as tarlatan) with a tape at the waist. A roll of wadding at the waist makes the skirt stick out more. There is also an 'undergarment' consisting of a strip of the same fabric wound into place (fig.18). Under magnification the individual fibres looked as if they had large blobs of a yellowish material with small dark particles adhered to them. The yellow material was identified as animal glue. No traces of pigments or dye were found and the dark particles appeared to be dirt. As the dirt was bound in with the glue and they were both evenly distributed over the whole skirt, it perhaps was dipped into a dirtied glue mixture. This would have had the effect of both stiffening it and giving it an aged appearance to match the original.[12] The skirt, though obviously delicate, was sound and there was no reason to replace or clean it, having discovered that its dirty appearance was deliberate.

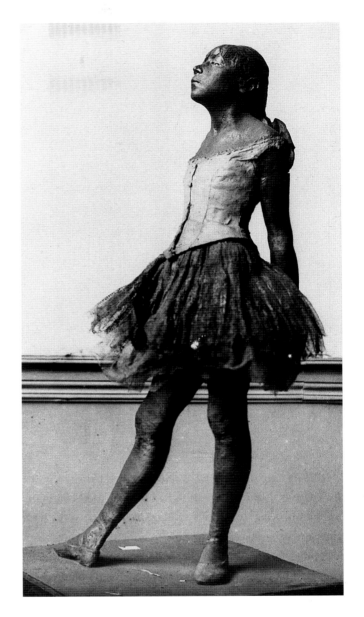

ABOVE Fig.17 Inventory photograph taken in Degas's studio after his death

LEFT Fig.18 A view of the 'undergarment' consisting of a strip of the same fabric the skirt is made from wound into place

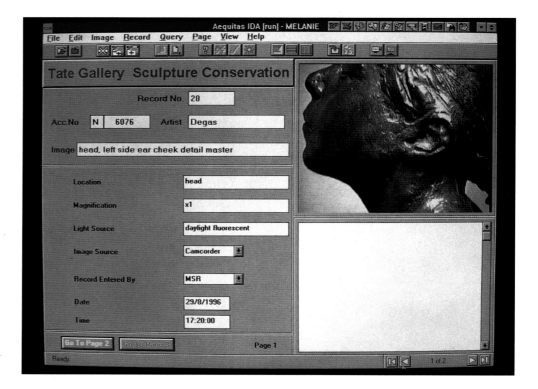

Fig.19 A page from the video image database

The examination revealed that far from being dirty the *Little Dancer Aged Fourteen* was in fact in very good condition, probably owing to always having been displayed under glass and never loaned. The only treatment undertaken was a light surface clean and the replacement of the original ribbon. The ribbon was found to be a cream-coloured silk of a fine satin weave and thought to be original to the Tate's cast. Numerous casts have replacement ribbons. The silk had degraded to the extent that the ribbon appeared shredded. It was fully documented and photographed before removal and is now preserved in an acid-free container in the Tate Archive. A new white satin silk ribbon of the same width and length was bought in Paris, dyed to match the original one and tied in exactly the same way.

Even though the sculpture is in good condition, preventing future deterioration is important. The sculpture should remain stable provided it is not subject to the physical stresses of movement, including vibration, and the environmental conditions remain constant and at low humidity. A new case was designed which minimises the danger

of movement and allows for internal environmental control if the exterior conditions are unsuitable. In addition it provides a buffer against air pollution which can also be very damaging to some materials.

Lighting the *Little Dancer Aged Fourteen* is problematic; the textile elements in particular could be damaged by high light levels and have probably survived so far because the sculpture has never been very well lit. However, in order to appreciate the vitality of the surface which, as this investigation revealed, is so important to the piece, it was felt the lighting should be improved. The piece is now spotlit but the particularly damaging UV rays are filtered out and light levels are monitored and kept low.

Because the *Little Dancer Aged Fourteen* is permanently on display and access to her is limited, we decided to make a very thorough visual documentation part of this conservation project. Much of the close examination was done using a video microscope. Instead of looking down through eye-pieces at the magnified image as with a conventional microscope, the colour image is transferred via a video

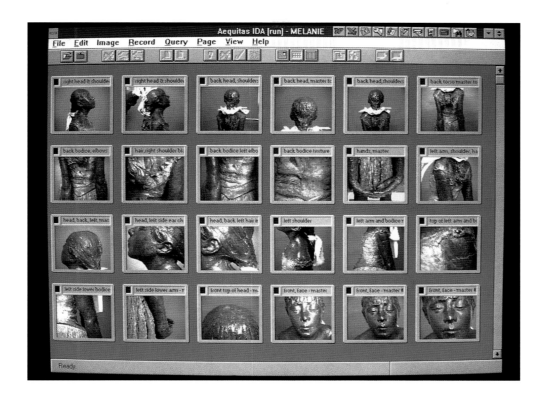

Fig.20 'Gallery view' of images in the database

probe on to a computer screen. The magnified images can then be 'captured' and stored on the database.[13] Each image appears on a 'page' on which there is also space for written information, detailing location, magnification, etc. (fig.19). In order to locate the magnified images, pictures of the whole figure and of recognisable details were captured on to the database using an ordinary video camera linked into the computer. These were then annotated on the computer to pinpoint the areas which would appear in magnification (fig.20). It is now possible, using the database, to look over the whole sculpture, homing in on interesting details and examining them at different levels of magnification on subsequent pages of the record.

This study helped to give insight into the techniques used by the foundry after Degas's death. The *Little Dancer Aged Fourteen* is arguably the most important of Degas's sculptures, it is certainly the one in which colour and variety of surface play their most significant part in the effectiveness of the original. The extent to which the foundry applied colour over the whole surface of the bronze was

revealed for the first time by this investigation. It is hoped that this study and the video image database which documents it will serve as a useful reference for other conservators studying casts of the *Little Dancer Aged Fourteen*. Although the x-ray examination was less conclusive, the images will continue to yield information about the foundry's casting techniques once other casts are x-rayed and comparisons can be made.

Dr Joyce Townsend and Melanie Rolfe used optical microscopy to identify pigments. Py-GC-MS was carried out by Dr Tom Learner, and thermomicroscopy, staining reactions for proteins, and immersion of microscopical samples in refractive index liquids by Dr Joyce Townsend, in order to identify the coatings, and the stiffening of the skirt. X-radiography was carried out by Parks Radiographic Inspection Co., Swindon.

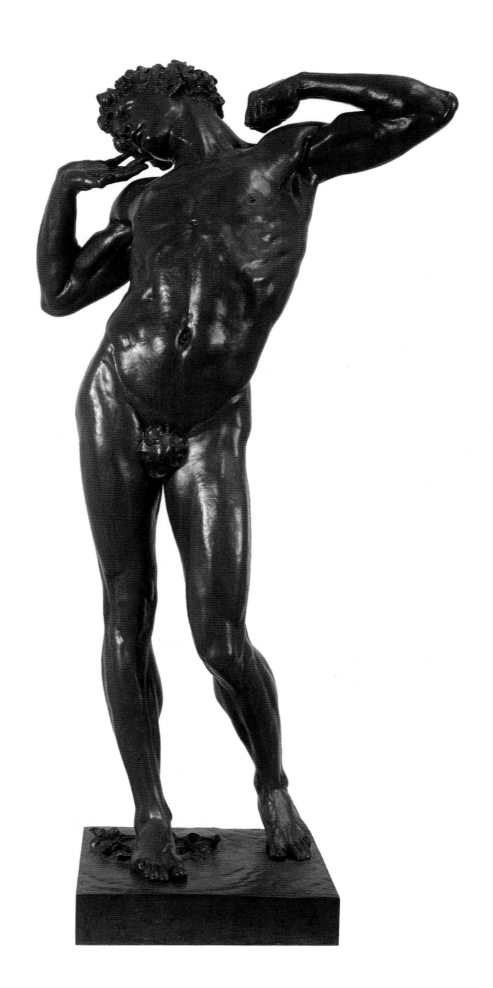

The Sluggard 1885

FREDERIC, LORD LEIGHTON
(1830–1896)

Jackie Heuman

During the course of the conservation of Frederic, Lord Leighton's *The Sluggard* (1885), some surprising findings about the techniques and materials used to colour this bronze sculpture were revealed. The various methods of bronze casting are well known from historical documentation and modern technical studies. Relatively little is known, however, about patination techniques of colouring metals which were (and to some extent still are) a trade secret jealously guarded by specialist patinators in foundries. Because of this, patination recipes were generally undocumented and details of many original colours on nineteenth-century bronzes are lacking. Today, we are much more careful to ensure that colours are documented and that conservation treatments do not adversely affect the patina.

Leighton, best known for his paintings, was also a major figure in the history of British sculpture. He made two significant bronze sculptures besides *The Sluggard* (fig.21) which are also in the Tate's collection: *An Athlete Wrestling with a Python* (c.1877) (fig.22) and *Needless Alarms* (1886) (fig.23). Leighton made clay models as preparations for his painted compositions, but his first independent sculpture, the life-sized bronze *An Athlete Wrestling with a Python*, was not exhibited until late in his career, in 1877. From its first appearance, the sculpture was recognised as a major work of art, symbolising the shift from neoclassicism towards naturalism that marked the new sculpture movement in

Fig.21 *The Sluggard* (1885) after conservation treatment, 191.1 × 90.2 × 59.7 cm, 285 kg. N01752

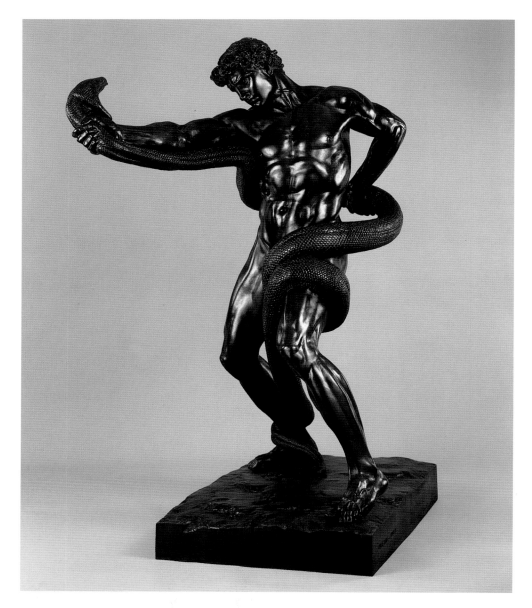

Fig.22 *An Athlete Wrestling with a Python* (c.1877)

Fig.23 *Needless Alarms* (1886)

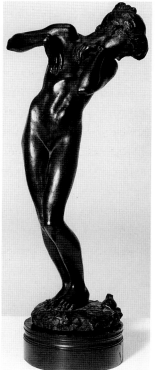

Britain in the 1880s and 1890s. *An Athlete Wrestling with a Python* became the icon of the movement christened by the critic Edmund Gosse as 'New Sculpture'.[1]

 The Sluggard, Leighton's second sculpture, was exhibited at the Royal Academy in 1886 and was bought by Henry Tate in 1894 for the Tate Gallery. The larger-than-life-size bronze is of a nude muscular male in a stretching pose. He stands on an integral base, a laurel leaf wreath beneath his right foot. Leighton was inspired to create *The Sluggard* when his model, Giuseppe Valona, 'a man of fine proportions, weary one day of posing in the studio, threw himself back, stretched his arms and gave a great yawn. Leighton saw this and fixed it

roughly in the clay straight off.'[2] Like many sculptors, Leighton made sketch models in wax or clay. He said 'I have tried wax, but on the whole I do not like it so well.'[3] He began to work on the clay model of *The Sluggard* in the early 1880s and scaled the sculpture up to full size in 1885 in the studio of his friend, the sculptor Thomas Brock. A mould would have been taken from the clay original and a plaster cast made as the first step in the bronze-making process. The artist would have had the opportunity to rework the plaster at this point before the final bronze casting.

In the late 1880s London foundries were offering both traditional sand-casting as well as the more recently introduced lost-wax techniques.[4] *The Sluggard*, however, was cast using the sand-cast technique in which the plaster parts were half-buried in a bed of sand held in a rigid metal frame. The plaster was dusted with a separating layer such as talc and the exposed top half-covered with a series of small carefully moulded sand pieces that interlocked firmly together. The same process was repeated for the lower half of the mould and then the plaster was taken out without disturbing the fine sand mould.

When the two metal frames were put together, a void was left where the plaster once occupied the space. A core was made to fill the negative space in the sand mould by packing a mixture of fine sand and plaster over a metal armature to create a porous inner form. Once the core filled the cavity a layer of one-eighth to three-eighths of an inch was scraped off its surface to create a space between the core and the sand mould. This was eventually filled with molten bronze. For reasons of economy and ease of handling, bronze sculptures were, and continue to be, usually cast hollow. A channel was cut into the sand to allow the molten metal to flow into the mould while it was supported in a casting pit. It was usual for sculptures of this size to be cast in pieces, which allowed the size of the moulds to be within manageable proportions. *The Sluggard* was divided into five separate sections: the torso with head attached, and the separate arms and legs.

After the bronze had solidified and cooled, the sand was removed from the cast sections to reveal the form. The cast parts of *The Sluggard* were then joined together by a technique known as Roman joints, in which a carefully shaped peg, integrally cast to the limb, was fitted and pinned into a

LEFT Fig.24 Diagram of a Roman joint

BELOW Fig.25 An undated photograph taken while the sculpture was in the Tate's collection, showing *The Sluggard* in excellent condition with a smooth even surface finish

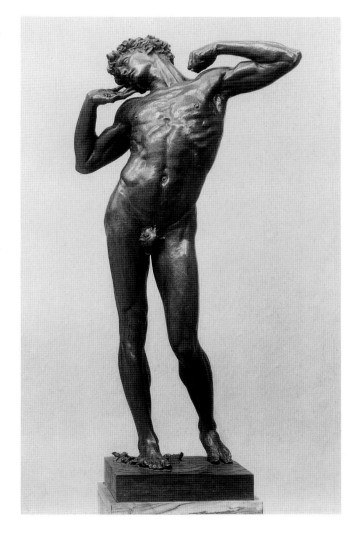

matching socket (fig.24). The bronze figure would have been cleaned by filing down projections on the exterior surface and along the mould lines (metal often leaks out into the cracks between the pieces of mould). The foundry worker (chaser) would then have worked on the surface detail using files, chisels, rasps and other tools before a patina was applied.

Little is known about the early state of *The Sluggard*. An undated black and white Tate photograph (fig.25) shows it in excellent condition with a smooth even surface finish, but the display history of the sculpture was not documented until 1969 when it was put outdoors in the garden of Leighton House. At that stage it had a brown patina but, when it was removed to the Tate Gallery sculpture conservation studio fifteen years later, the original patina was visible only on about half the sculpture. *The Sluggard* was examined to determine its composition and method of fabrication. It is important to appreciate that when a bronze sculpture has been displayed outdoors and is superficially examined, we are seldom looking at the original surface, but at layers of corrosion products. A black corrosion crust, approximately 1 mm thick in places, covered much of the

surface and obscured the fine modelling of the figure. Fig.26 shows details of the sculpture with the corrosion pattern that typically occurs when a sculpture has been displayed outdoors. Water run-off on exposed parts such as the chest had caused bare green patches (fig.27) and vertical green streaks ran down the legs, arms and back.

Examining the surface with a low magnification binocular microscope, one of the conservator's most useful tools, sometimes reveals clues about what the sculpture may have looked like originally. This type of information not only helps to give a basis for deciding on an appropriate treatment but can provide insights for art historians. For instance, on examination of the base of *The Sluggard*, a few flecks of gold could be seen on the laurel wreath. Further examination under the microscope revealed that the gold was applied over the brown patina. Although this suggests that the wreath was originally gold, we cannot be sure. An 1886 review in the *Art Journal* described *The Sluggard* as a 'life size bronze figure of an athlete content not only to rest on the laurels he has won, but to trample them under foot, for his gilded wreath is lying in the dust'.[5] This is the only

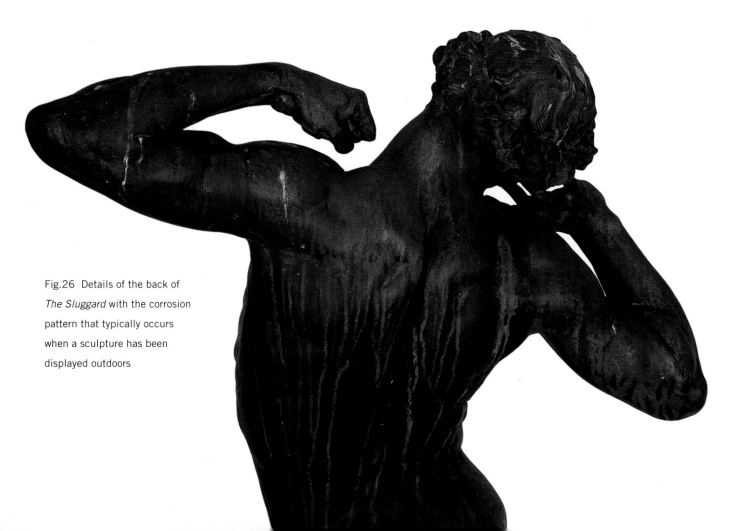

Fig.26 Details of the back of *The Sluggard* with the corrosion pattern that typically occurs when a sculpture has been displayed outdoors

reference found to date that suggests the wreath was gilded,[6] but the reviewer might have been using poetic licence. If the wreath was originally gilt, it would have dramatically altered the appearance of the work. Although this raises very interesting possibilities both art historically and from the conservation point of view, we do not yet have enough evidence to confirm that the wreath was once gold and therefore for the moment it will not be regilded.

The objective of the conservation treatment was to reveal as much as possible of the original patina. The term patina is commonly associated with a coloured coating on a metal produced at the foundry by applying chemicals to a heated surface. Various cleaning solvents for typical chemical patinas were discretely tested on the surface of the sculpture. Unusually a solvent was able to remove the brown, exposing an underlying green colour. It is highly unlikely that a solvent could have so easily affected the patina had it been chemically applied. Analysing the chemical composition of the patina can give clues about the original materials used by the artist or foundry. Tiny samples were taken and iron oxide, chrome yellow and

lead white pigments were identified in an oxidised linseed oil binder. This was a surprising discovery. It meant that the bronze had been painted with an oil paint and cross-sections showed that the translucent paint had been applied in two layers. If this was original, it is likely that Leighton, an artist primarily interested in painted surfaces, painted the sculpture himself. Although painting a bronze was not common practice for sculptors or foundries, Leighton's contemporaries such as Edward Onslow Ford and most notably Alfred Gilbert were experimenting with the use of colour on sculpture (see pages 34–41). What is remarkable is that the painted surface so resembled a corroded, chemically applied patina and that, after fifteen years outdoors, so much of the original paint remained.

Analysing the bronze used in the original casting can help us predict which corrosion products and potential problems to expect. The analysis of the bronze was consistent with what has been found on other bronzes (90 per cent copper and 10 per cent tin) from this time and did not disclose any unforeseen problems. The black crust often seen on outdoor bronzes is commonly due to the accumu-

Fig.27 Water run-off on exposed parts of *The Sluggard* such as the chest had caused bare green patches

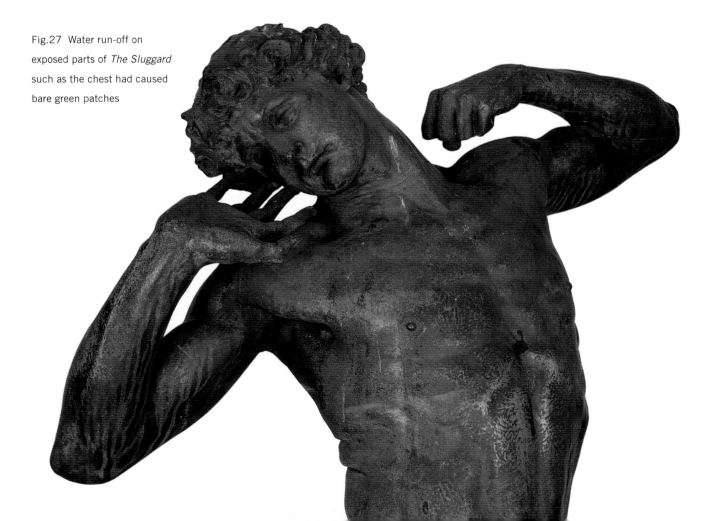

LEFT Fig.28 A cross-section (× 400 magnification) taken from the hair shows that the surface is made up of three irregular but distinct layers. The outermost (top) layer is the black corrosion crust followed by the brown paint layer and below this is the green (chloride) layer

OPPOSITE Fig.30 Detail showing the figure's right leg after cleaning, with vertical green streaks

lation of particulate matter with copper sulphides and sulphates. But when the black crust on *The Sluggard* was analysed, copper chloride was found to be predominant. There is no evidence to suggest that *The Sluggard* has had any contact with a major chlorine source while outdoors , and on a sculpture placed remote from the sea, this is highly unusual.

Where then did these chlorides come from and what information does this give us? Although it is not unusual to find some chlorides below a patina layer on outdoor bronzes, the presence of such a large chlorine-rich zone on *The Sluggard* suggests that chlorides may have been supplied from a non-environmental source. Since the cleaning tests revealed an underlying green layer below the paint, the chlorides may have come from a chemical patinating solution containing ammonium chloride which was widely used for producing green patinas. If the bronze had first been chemically patinated with a green ground by the foundry, Leighton may have then painted a translucent brown layer over this, which would have given a greater richness and variety of coloured effects to the bronze finish. As seen in fig.28, a magnified cross-section taken from the hair shows the surface to be made up of three irregular but distinct layers. The outermost (top) layer is

ABOVE Fig.29 A test done on the figure's back with a poultice was very effective at removing the corrosion to reveal the original brown patina

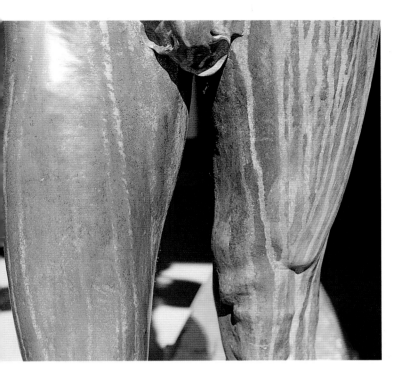

paint could take place. To help minimise contact with the paint and bronze surface, a poultice was made up with the chelating agent and a thickening gel. The test poultice was very effective at removing the corrosion to reveal the original brown patina (fig.29). Once it was established which chelating agent was most effective, the poultice was analysed to determine what was being extracted and the treatment was begun.

A two-step process was developed to treat the variable thickness of the corrosion crust. Care was taken to avoid poulticing areas where the paint was already exposed. Each poultice was left in place for three to five minutes and it took several applications before the corrosion was soft enough to be removed with gentle mechanical action using cotton wool or plastic tools. The area was then thoroughly rinsed with de-ionised water to ensure that all the chelating agent was removed from the sculpture.[9] When the black corrosion crust was removed, the underlying brown paint was patchy in some areas but surprisingly well preserved overall revealing the surface details and textures.

Although the appearance was greatly improved, the vertical green streaks and areas of eroded paint were still disfiguring (fig.30). A final decision was made to retouch the green streaks to match the original brown using ground pigments in acrylic resin. This retouching can be removed in the future without affecting the original paint. Finally a protective coating of microcrystalline wax was applied over the surface to unify the piece.

The treatment took about four months and transformed the sculpture by revealing the subtle translucent brown patina and sculptural detail which had previously been obscured. To preserve its delicate surface the sculpture will hereafter be displayed indoors. Since patination has been investigated on only a few nineteenth-century sculptures, it is an intriguing possibility that other bronzes from this time might also have originally had delicate painted finishes.

Analysis of pigments was done by Dr Joyce Townsend using EDX and optical microscopy. Analysis of bronze and corrosion products was done by x-ray diffraction, EPMA and LIMA and the ion content of the corrosion product and the poultices were characterised with ion chromatography by British Petroleum's Research Centre.

the black corrosion crust followed by the brown paint layer and below this is the green (chloride) layer.

The challenge was to remove the corrosion, without disturbing what remained of the original painted patina. All patinas change with exposure to the atmosphere. The 'natural' green patina found on many ancient works has come to be valued despite evidence that they were not originally green. 'A patina of age that authenticates or preserves antiquity is apt to be thought aesthetic.'[7] Some art historians argue that an untouched patina, although changed by exposure, is still the 'natural' patina and should not be tampered with even if original colours were documented.[8] Yet Leighton probably did not intend his work to become camouflaged with green and black streaks, and although we were fortunate that so much of the original colour remained, it was necessary to remove the corrosion so the fine sculptural form could once again be seen.

The complex corrosion and paint structure meant that cleaning was not going to be easy. To investigate the removal of corrosion without damaging the underlying paint, tests using different chemical compounds known as chelating agents were carried out. In theory, a chelating agent would extract the more accessible ions first, weakening the outer corrosion before any significant attack on the

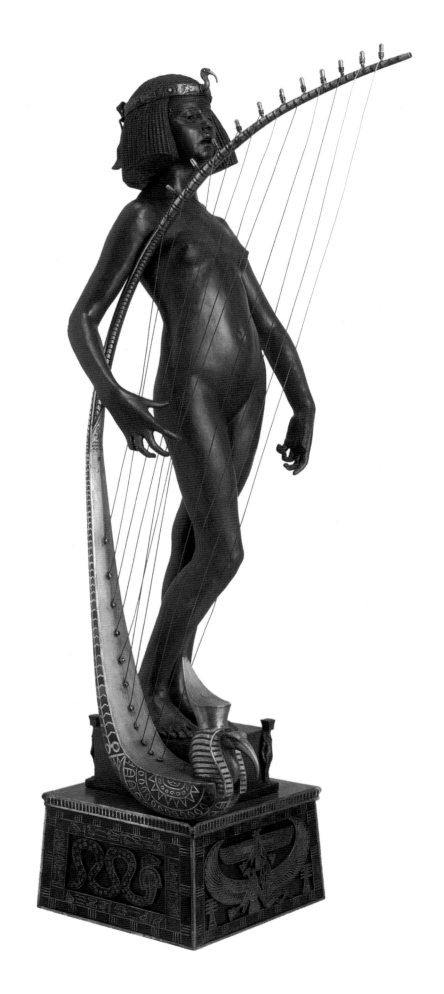

The Singer 1889

EDWARD ONSLOW FORD (1852–1901)

Pip Laurenson

Recent exhibitions in Britain and the United States have rekindled an interest in Victorian art and aesthetics. However, for many years Victorian sculptures such as Edward Onslow Ford's *The Singer* were distinctly out of fashion. This may in part explain the past history and treatment of this sculpture. *The Singer* is an example of a highly ornate aesthetic, but for years the colour of the surface and fine ornament were hidden under a thick layer of brown wax. Just as the Victorians reacted against the neoclassicism of the eighteenth century, so modern taste reacted against the decorative use of colour and ornament of the Victorians. Many sculptures in the Tate's collection have been treated in the past and in some cases this has altered not only the appearance but also, as a direct consequence, the historical perception of these artworks. These treatments sometimes reveal more about the tastes of the restorers and their contemporaries than the artist's original intent. Awareness of this has made present conservators much more cautious about changing the appearance of a work unless there is very good evidence that this was how the artist intended the work to look.

Edward Onslow Ford's *The Singer*, completed in 1889, depicts a girl harpist on a base decorated with Egyptian motifs (fig.31). The sculpture is a fascinating document about the Victorian perception of other cultures subsumed under the notion of 'Orientalism' and reflects the sculptor's interest in experimenting with different techniques. Ford, a British sculptor who has received only limited

Fig.31 *The Singer* (1889) after conservation treatment, 91.2 × 26 × 45 cm, 34.4 kg. N01753

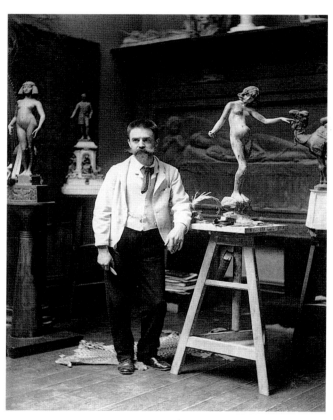

Fig.32 Edward Onslow Ford
in his studio photographed
by Ralph Robinson *c*.1891
(Courtesy of the National
Portrait Gallery). *The Singer* can
be seen on the left-hand side

attention from art historians, was a close friend of Alfred Gilbert. Gilbert and Ford occupied neighbouring studios in the mid-1880s and collaborated in reviving lost-wax casting (fig.32).[1] As a young man Ford had trained as a painter in Munich and therefore probably had a good knowledge of pigments and the use of colour. Ford was also in Germany at a time when debates were raging about the use of colour in sculpture sparked by the discovery of pigment on recently excavated works from antiquity.

An 1898 Tate Gallery catalogue entry describes *The Singer*: 'A girl with an Egyptian head-dress stands on a small bronze base with Egyptian figures at the corners; with her right hand she strikes a chord on a tall enamelled Egyptian harp that stands at her right side. The brass base is decorated with Egyptian symbols in coloured enamels. The whole is supported on a bronze lotus-shaped pedestal inserted in a black marble base.'[2] However, in 1994, when the sculpture came to the conservation studio, it was uniformly dark brown, suggesting a darkly patinated bronze (fig.33). Thus early descriptions of the piece and even a fairly brief examination indicated that there was more to be discovered about the surface than its superficial appearance suggested.

It is clear that Ford had not intended his sculpture to be a dark brown but our preliminary task, before treatment could be carried out, was to determine what the sculpture had originally looked like. Unfortunately there is no archive for Ford, or any existing notebooks or correspondence which might have described how he made this sculpture. There are, however, two clues as to how *The Singer* looked when it left Ford's studio. There is a 'sister piece' called *Applause* made slightly later, in 1893. Tantalising images in black and white (fig.34) show significant stylistic similarities especially in relation to the decorative motifs of the base.[3] We managed to trace the sculpture through the wills of the family which had originally bought the sculpture from the artist.[4] Luckily the sculpture was found privately owned. Many Victorian sculptures are cherished family objects unknown to art historians and it was a delight to be able to see this sculpture so well looked after. However, although stylistically very similar, the techniques employed to create *Applause* were very different from those used in *The Singer*.[5]

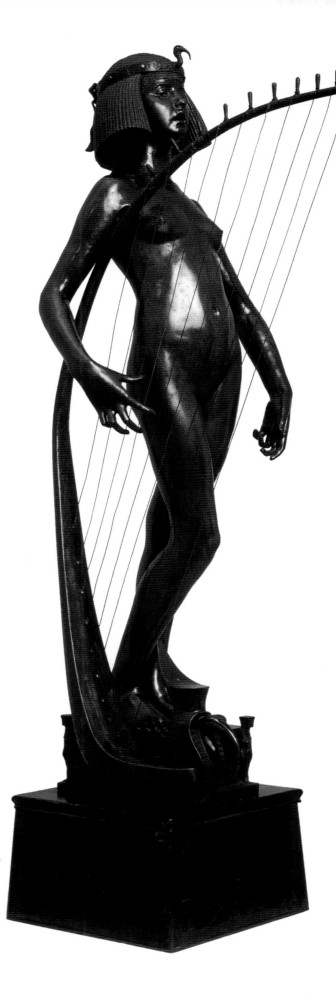

Fig.33 The sculpture
with the overall brown coating
covering the surface

The second clue was discovered in a black and white photograph of an oil painting by the sculptor's son, Wolfram Ford, entitled *My Father*, which showed *The Singer* in the background (fig.35).[6] This offered the hope of a rare colour representation of the sculpture, but sadly the painting remains untraced, perhaps destroyed. The best clues to the original appearance of the colourful enamel decoration, therefore, remained those within the early catalogue description.

Such examples illustrate how difficult it can be to find documentation about the appearance of an even relatively recent work, a problem compounded if one is interested in something as elusive as colour. We therefore had to rely on microscopic examination and chemical analysis of the surface to reveal information about the original materials and techniques used.

The casting technique appears to be lost wax. The harp was cast in two pieces and soldered together. A minute sample of metal taken from the harp identified it as bronze rather than brass as earlier described. The three elements are attached by bolts; the harp and base are bolted to the figure. When the harp was detached, cells of bright blue and pale red were seen in a protected area. It looked like cloisonné enamel and, initially, was thought to be a badly fired, but conventional, glass enamel. However, when it was analysed,[7] much to our surprise, it was not a true glass enamel at all but a mixture of chalk (calcium carbonate) and pigment bound in an oxidised natural resin.

The base comprised four panels and the cloisonné-type cells were made from copper or brass strips and soldered to the back plate. With traditional cloisonné the thin strips of metal are soldered to the surface forming the outline of the pattern and creating cells or cloisons into which the

powdered glass enamel is laid and fused. In this case, rather than using powdered glass, resin was pushed or poured into the cells, covering the screws and completing the decorative scheme. A blue resin mix filled the whole panel, and the red resin was then added over it in selected areas. Here and there, the red appears to have spilled out of the intended areas, suggesting that the resin paste was not easy to control. The surface was then polished to an even level.

Information on historical precedents for the use of resinous material in making what is essentially a fake enamel remains scant. The Victoria and Albert Museum has several medieval plaques with coloured inlay resembling that found on *The Singer*. Also, some contracts for medieval brasses specified resin-based inlays, but because this material is less durable than true enamel, few have survived intact.[8]

Analysis helped identify the constituents of the resin inlay as well as the coatings over it. Edges of the 'enamel' that had been chipped or broken also provided useful information since they revealed the inlay beyond the surface structure. The red and blue colours were not simply paint layers which had been applied to the surface but rather pigments that had been mixed into the resin. The pigments were identified as Prussian blue and Mars red. Identifying the pigments was important in this study, as different pigments age in different ways, and may be chemically reactive, limiting the possible materials that might be used in cleaning.

When the conservation record began in 1978, the coating on the sculpture was said to have darkened to a black colour. What had happened to the colourful 'enamel' underneath? In fact there had been no darkening of the coating. Rather, the surface had been coated in a dark brown wax, most probably beeswax; a treatment used on many sculptures from this period. It is unclear whether this treatment was meant to cover a damaged or deteriorated surface or was simply a standard 'maintenance' treatment. Removing the wax might leave the sculpture looking worse so cleaning tests were needed. When the wax was removed with a solvent, rather than finding the bright blue and red colours expected, a yellow brown crystalline deposit remained on the surface. This layer was found to be lin-

through a binocular microscope
(× 14) showing an area of the
base. The oil is visible on the
surface; on the right-hand side
the thin layer of red resin over
the blue can be seen

OPPOSITE Fig.37 Detail
shows the base half-cleaned

seed oil, which darkens as it ages. Had the artist applied the linseed oil after the sculpture was made as a type of varnish, which would have enhanced the blues and reds, or had this been applied later by a restorer?

Microscopy provided a possible answer as it revealed remnants of the discoloured oil layer over areas where the inlay had been lost or chipped (fig.36). That the oil went over these damaged areas suggests that this layer was a later addition, perhaps added to saturate and brighten the colours. However, it is also possible that the sculpture might originally have been coated with an oil and was recoated when it began to degrade. It is impossible to say exactly when the linseed oil was applied but, in order to reveal the colour of the sculpture, a method was needed to remove this deteriorated and darkened oil layer. This presented a complex cleaning problem.

Because the coloured resin was soluble in many of the substances that would dissolve the discoloured oil, it was difficult to remove the oil without damaging the resin. Several different cleaning options were considered; the one most extensively investigated was the use of an enzyme to break down the oil. The lipase enzyme has been used intermittently in the conservation of paintings and objects but is still relatively unexplored. Such enzymes occur naturally in the small intestine in humans as well as in other animals and were chosen because they can break down the oil into fatty acids. This is, of course, the same reason why they work to remove fatty stains from our clothes when they are added to biological washing powders.

In this application, unfortunately, the enzyme was not effective at removing the oil. The surface of most art objects is chemically complex and enzymes are temperamental. The age of the oil and the other materials such as remnants of wax, metal ions from the surrounding brass and oxides from the pigments may have contaminated the oil preventing the action of the enzymes. It was therefore decided that the safest and most effective way to remove the oil layer was a combination of mechanical and chemical cleaning. Mechanical cleaning was carried out using the fine point of a surgical scalpel under a microscope. Not only was this method slow but using a scalpel was difficult in some areas because the resin was pitted and irregular. Further tests were therefore carried out using an alkaline cleaner. Since an

alkaline cleaner could chemically react with the Prussian blue pigment in the inlay cells and change the colour to a brown/orange, extensive tests were first done. An effective mixture was safely formulated and used to remove the oil layer. Once cleaned the detail of the vibrant blues and reds in the base and harp were revealed and the Egyptian decorative surface could again be seen (fig.37).

The bronze figure was the final part of the sculpture to be cleaned. Initially we were not intending to remove the dark wax from the bronze, as it was not clear how much of the original patina would be found. Decisions about removing previous treatments always involve weighing up the risks and benefits: some restorations can be historically interesting in their own right, while any treatment will put the object at some risk. In this case, however, given the amount of colour revealed on the base and the harp, the dark wax remaining on the bronze disturbed the visual coherence of the sculpture and obscured the detail of the figure. The wax was removed using white spirit solvent revealing a green and brown patina, but the underlying oil was left as it was relatively undegraded and it did not distract from the appearance of the sculpture. However, a layer of neutral coloured wax applied to the surface helped unify the sculpture. Although there were areas of wear in the patina, the greens and browns of the original complemented the delicate surface of the harp and base (see fig.31).

Since the decorative scheme has been revealed there has been renewed interest in this piece, including its recent display in an exhibition about colour in sculpture.[9] *The Singer* can once more be understood in the context of highly decorative nineteenth-century sculpture, which is beginning to receive greater scholarly attention and public appreciation.

The 'enamel' was analysed with FTIR and Py-GC-MS by Dr Tom Learner. Dr Joyce Townsend carried out optical microscopy and EDX.

Fish 1926

CONSTANTIN BRANCUSI (1876–1957)

Melanie Rolfe

The first *Fish* Brancusi made was in a veined white marble mounted above a disc of mirror glass. Two years later he made two bronze versions (one of which was destroyed) and then in 1926 another four of which the Tate's version is one (fig.38). All but one of the surviving bronze *Fish* are mounted, like this one, above a reflective white metal disc attached at a single point so that it appears to be just skimming the polished surface. The series was completed in 1930 with a slightly larger version in blue-grey marble. Differences in size between the marble versions and the individual bronzes seem to indicate that Brancusi was testing the limits of possible dimensions for this particular horizontal form.

As with much of Brancusi's work, the apparent simplicity of the *Fish* is deceptive. At first sight the fish and the disc are some of the simplest sculptural forms he produced; but there is complexity in the relationship between them, and in how the forms relate to the materials from which they are made. Brancusi chose materials that recall the water in which the fish lives; rippling marble and mirror glass (fig.39). These are replaced in the later versions by bright, polished bronze and cool, reflective white metal discs. Brancusi's use of highly polished bronze in many of his works can be seen as complementing the pared-down forms by giving a surface with no distracting textural detail. However, paradoxically, the reflective gloss of highly polished metal also has the effect of obscuring

Fig.38 *Fish* (1926) after conservation treatment,
93 × 50.2 × 50.2 cm, 285 kg. T07107

Fig.39 *Fish* (1922)
(Philadelphia Museum of Art:
Louise and Walter Arensburg
Collection)

Fig.40 Photograph by Brancusi of a bronze *Fish* in the studio (Musée nationale d'art moderne, Centre Georges Pompidou, Paris)

the definition of the form, distorting the surface with reflections of its surroundings.

Brancusi's own photograph of a bronze *Fish* in his studio clearly shows that he was exploiting the polished quality of the material in this work (fig.40). The light is bouncing off the nose of the fish and streaking down its sides, the studio windows and other sculptures can be seen in it and all this is reflected in the polished plate below. The ambiguities of the highly polished surface echo the elusive character of the fish swimming through water. Brancusi said, 'When you see a fish you do not think of its scales do you … you think of its floating, flashing body seen through water … I want just the flash of its spirit.'[1]

The fish and disc sit on a wooden base, which is attached to a floor plate, made of ferrous metal with a black finish. The plate stabilises the piece, which is top heavy even without the fish placed on top. The wooden base stands off-centre on the plate to counterbalance the upper part which projects forward. Brancusi may have

intended or at least been struck by the contrast this makes, with the fish placed centrally on its disc. The circularity of the disc and the fact that the fish is fixed above it in such a way as to be rotatable show that there is no fixed viewpoint intended for the sculpture. Viewing the piece from different angles, the fish changes shape as you walk around, becoming almost invisible when viewed head on.

Brancusi had been making bronze casts from his marble sculptures since 1910, when he produced a number of casts from his *Sleeping Muse* sculpture. He gave such casts a variety of finishes, from a high polish to a partial dark patination, as on the Tate's version of *Danaide* (*c*.1918) shown in fig.41. However, the significant dimensional changes between the different bronze versions of the *Fish* show that these are individual sculptures rather than casts from a finished work. The artist would probably have used plaster casts to rework the piece prior to casting in bronze.

All Brancusi's highly polished bronzes are a pale yellow colour reminiscent of brass, which is an alloy of copper and zinc. We have not yet analysed the fish but, in general, small fine art foundries, such as those used by Brancusi, would have been casting in bronze.[2] Bronze is basically a copper tin alloy but it is often modified with small amounts of other elements, including zinc. The colour does vary, becoming less pink and more yellow if the copper content is decreased, and Brancusi probably requested a paler, yellow alloy.[3]

The highly finished surface of the fish offers no clues as to the method of casting and, as the cast is solid, we can learn nothing from internal or x-ray examination. While some of Brancusi's bronzes (such as the Tate's *Danaide*) have been identified as lost-wax casts, the simple, compact form of the fish would have been ideal for sand-casting. Brancusi might have preferred this method as it produces a more even quality of bronze with fewer hidden air bubbles, which if exposed during finishing would spoil the perfect surface.

Brancusi said of one of his bronzes, 'Since the moment the metal came out of the foundry all the work was carried out by my own hands and the hand polishing was also carried out by me.'[4] He worked the surface first with thinner and thinner files, then with finer and finer emery paper and finally with a buffing powder such as jewellers rouge.[5] Friends who witnessed the long sessions of polishing were reminded of the daily repetitive tasks of certain mystical disciplines that are like a form of meditation.[6]

Brancusi was very concerned with the upkeep of his mirror-like polished surfaces. In 1922 his friend and dealer Henri-Pierre Roché wrote a letter to the American collector John Quinn, who was organising an exhibition of Brancusi's work in New York, reminding him of Brancusi's instructions that 'the sculptures must be cleaned often and gloves worn when handling them'. In reference to another highly polished work the artist himself wrote to Quinn, 'To keep it brilliant you must have it wiped fairly often with a chamois skin'. Brancusi goes on to say that 'it would be better not to employ any professionals, for professionals sometimes know more than is necessary … if later on the patina gets to look badly, kindly advise me and I will attend to it'.[7] Lacquering the surface would have helped protect against tarnish but would have changed the reflection of the metal.

Brancusi clearly foresaw the problems of keeping the work as he left it and probably anticipated that it would be polished using mild abrasives, which if carried out continuously would eventually remove his own hand finishing. Unfortunately this is the only way to remove a certain level of tarnish so Brancusi's strategy for prevention, by not handling and regularly wiping the surface to remove pollutants rather than polishing, was sensible. We still retain this policy of polishing as little as possible but this is often difficult in a gallery environment where the piece is displayed without a cover and its tactile nature tempts visitors to touch it.

A small steel pin attaches the fish to the circular disc. The discs used by Brancusi are usually described as being chrome-plated steel but a very slight yellow cast to the metal was more suggestive of nickel. When the piece came into the conservation studio in order for the fixing between the fish and the disc to be made more secure, a small sample of metal was taken from inside the hole in the disc. This was analysed and found to be an alloy of copper, nickel and zinc, commonly known as nickel silver and often used as a base for silver plate.

Although no traces of silver plate remain, the remnants

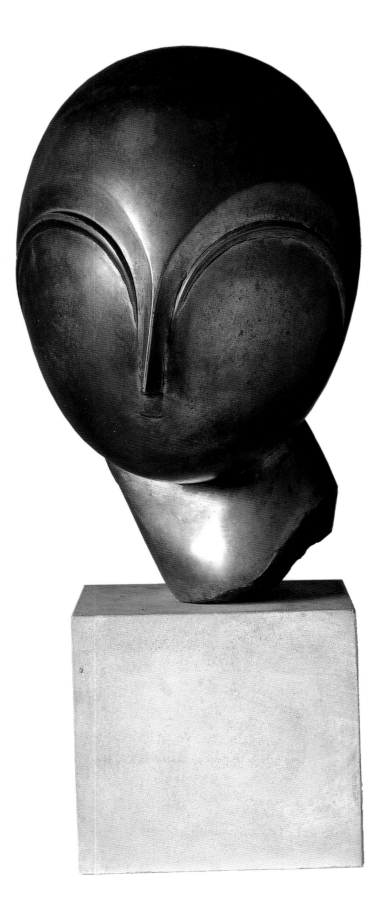

Fig.41 *Danaide* (*c*.1918)

of a lacquer can be seen towards the edges of the underside, which might have been applied to protect the easily tarnished silver. Subsequent polishing could have removed both the lacquer and the thin layer of silver plate and the nickel silver could itself have been polished to a high gloss. It is known that Brancusi was supplied in 1927 with two smoothed and polished circular discs by Bridanet and Co. and in 1932 he was sent an estimate for two much larger electroplated (which may mean silver-plated) discs

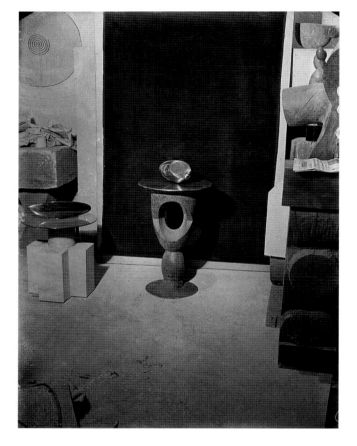

ABOVE Fig.42 Photograph by Brancusi taken in 1928 showing a different sculpture (*Newborn*) on the base now associated with *Fish* (Musée nationale d'art moderne, Centre Georges Pompidou, Paris)

OPPOSITE Fig.43 The upper part of the base before restoration, showing the wood fillets used to fill splits in the wood.

'polished to a brilliant finish on one side and all around the edge' from the firm Schneider and Co. It is most likely that the disc for *Fish* was also commercially supplied.[8]

Since leaving Brancusi's studio, the Tate's *Fish* has been associated, and always displayed, with a wooden base carved by the artist.[9] The relationship between Brancusi's sculptures and such bases is complex and there has been some debate as to whether they can be classified as works of art in themselves. This is further complicated by the fact that while some of the bases are elaborate shapes with a high level of finish, others are basic and rough-hewn. The Tate's base combines a more complex form and a greater degree of stylisation and surface finish than in most of his bases and recalls a remark by Roché: 'Brancusi has made some absolutely splendid bases, one of them is as beautiful and elaborate and great as one of his sculptures.'[10]

Brancusi was very concerned with the way sculptures were displayed. He was very distressed by photographs he saw of the New York exhibition in which his works were ranged along the walls on large traditional square pedestals – Roché told Quinn that Brancusi was 'as sore and sensitive as a child weeping over his toys'. The bases could be seen as a way of ensuring that this did not happen again. They are not merely to set the pieces off but to give them a properly defined position in space and it seems Brancusi was reluctant to send some of his sculptures out into the world without them. However, it is known that a number of bases were sold separately and that, in the studio, Brancusi often experimented with different combinations of sculptures and bases.

In one of Brancusi's photographs from 1928 (fig.42) the base in the Tate can be seen supporting another highly polished bronze piece, *Newborn*, while a bronze fish on a disc (possibly the one described here) rests on a plain geometric stone base next to it.[11] However, in changing bases around, Brancusi was not merely trying to see which would best suit which piece. The method of combining forms and creating ensembles can be seen throughout his work. One critic has likened the bases to musical instruments that set the sculptures resonating to produce different sounds.[12] The Tate's base may not have been made exclusively for this sculpture but it is in tune with it and it is likely to have been produced at around the same time in

the mid-1920s. It is possible that the strong rippling markings of the grain of this wood, which are very noticeable in the 1928 photograph, drew Brancusi to partner this base with *Fish*.

Brancusi used a variety of woods in his work, usually of European origin: poplar, walnut and oak, occasionally lime or maple and more rarely fruitwood. Most of the bases are of oak, carved from old oak beams, which he acquired from demolition contractors. The pronounced markings and rich reddish colour of this base do not immediately suggest oak but this has been confirmed by analysis. A recent article by conservators working on pieces in the Atelier Brancusi, Paris, notes that several pieces appear to have been tinted red and that it is not yet certain whether or not this was applied by Brancusi.[13]

It is important to remember that the methods Brancusi used to create sculpture, by carving directly into wood or stone, represented a break with the traditional, academic training. The academic emphasis had been on modelling forms, which might then be rendered in stone using a complicated method of transfer by a stone carver. Brancusi's very first artistic training was in wood carving, which he studied at the School of Arts and Crafts in Craiova in his native Romania. Although he then went on to receive a more academic training both in Romania and Paris he returned to carving as early as 1907.

Brancusi was aware of the differing qualities and potential of materials and was convinced that they must not be worked in the same way. He recognised that 'wood has its own forms, its individual character, its natural expression: to want to transform its qualities is to render it sterile' and added 'you cannot make what you want to make but what the material permits you to make. You cannot make out of marble what you would make out of wood, or out of wood what you would make out of stone.'[14] Photographs show Brancusi roughing out the shape of *Endless Column* with an axe and marks on the surface of the base for *Fish* suggest it may have been finished using a small adze.[15] These methods recall Brancusi's main inspirations for his wood carving, African wood sculptures and traditional Romanian carving.

The young artists who assisted Brancusi in later years[16] testify as to his working methods, particularly his attitude

to tools. Brancusi was very keen on the importance of using each tool precisely for its intended purpose and on looking after them so that they could be used without forcing either the tool or the material. The enormous saw, which Brancusi used to cut up the large beams, was kept so sharp that it could cut using only the action of its own weight without the need to apply pressure. Despite his interest in traditional techniques, in later years he was very fond of buying new types of tools, including a machine with chamois, felt and cotton disks for polishing his bronzes.

The uncompromising, honest approach to the material, which characterises most of Brancusi's oak sculptures and bases, seems tempered in this piece by an interest in creating a more smooth and finished effect. Brancusi was known to have filled splits or knots in some of his wood sculptures with thin pieces of wood or with a wood filler which were then covered with shellac to unify the surface.[17] As fig.43 illustrates, it seems likely that he used a

similar method when making this base, to prevent splits from interrupting the smooth, rounded surfaces and distracting from the unusually complex form.

Some time before this piece came into the Tate collection the base was the subject of a major and very necessary restoration. Damp had affected the wooden base leading to the growth of a fungus, which in turn provided the conditions for an attack of deathwatch beetle. Reports of this treatment document that the network of tunnels and flight holes had riddled almost all of one side as well as the central cavity. The damage was far greater on the inside than could be discerned from the surface so that the structural integrity of the piece was threatened and half of the bottom part was almost detached. After treating the infestation, the wood was painstakingly consolidated and filled with resin on the inside to restore the structural strength.

Thanks to this earlier conservation work, the base was structurally stable when it came to the Tate. However,

there were problems with the surface (fig.44). The side where most of the damage had occurred appeared to have faded owing to light damage and the wood looked paler and more yellow, so the pattern of the grain no longer stood out. Although we presume that the restorer had inpainted the fills to match the surrounding wood, they now appeared as distracting red patches. As well as the wood fading, it is also possible that the inpainting may have darkened as it aged. The texture of the adze marks had been irretrievably lost on this side as a result of the damage and the subsequent restoration. The whole area appeared dryer, and the colour less deep and glossy, than on the undamaged side.

The piece was treated to improve the appearance of the surface and restore the effect of the rippling graining of the wood. A furniture wax pigmented with earth colours (which would be light-fast) was used to give a richer, warmer finish to the damaged side and bring it in line with the rest of the base. The coloured wax was applied only

between the pale areas of graining so that the rippling pattern was once more apparent. The previously applied red inpainting was removed and the fills resurfaced and prepared for repainting (fig.45). This was done using very finely ground, non-opaque pigments in a stable acrylic medium (fig.46). It was necessary to evolve a technique of building up colour in layers of washes to achieve the combination of depth and transparency that characterised the surface appearance of the polished wood. Since the colour and transparency varied considerably across the whole surface of the wood, this was a time-consuming and laborious process.

It was also necessary to improve the fixing of the fish to the disc. The original fixing was made from a steel pin that screwed into the bronze fish and sat in a hole in the centre of the disc. Because this hole was slightly larger in diameter than the pin, some fuse wire had been wrapped around the pin so it fitted more snugly in the hole. This was not secure so a new fixing was devised to ensure that

while the fish could not be lifted off the disc it could still be rotated as Brancusi had intended. The threaded hole inside the fish had become worn and, rather than retap it, we felt it was less invasive to adapt the new fixing to it. The thread of a new stainless steel bolt was gradually ground down until it screwed in easily.

Brancusi's interest in the care of his works after they left his studio illustrates his awareness of the fragility of his work. With Brancusi, the final stages of execution and the physical processes of finishing and polishing which enhanced the natural qualities of the materials, are at the core of his art. In our treatment of the metal parts of the sculpture, our aim is to preserve this by interfering as little as possible. In the case of the base, more intervention was necessary to restore both the beauty of the wood and the balance of the ensemble.

Dr Joyce Townsend carried out quantitative EDX and Nicholas Umney identified the wood by optical microscopy.

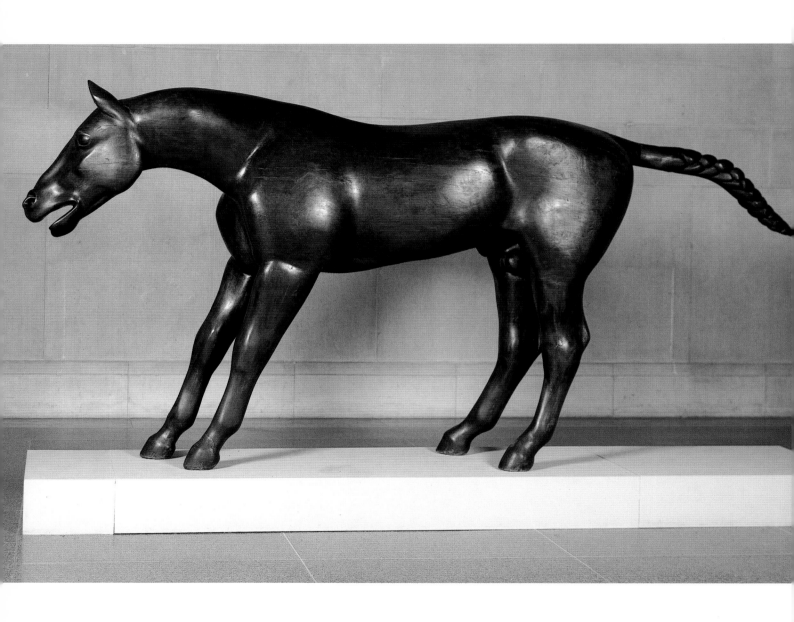

The Horse 1933

JOHN SKEAPING (1901–1980)

Sandra Deighton

The Horse (fig.47), a life-size wood carving, was John Skeaping's most ambitious project. It was, according to the artist, 'a colossal undertaking'.[1] He was helped by his student, sculptor Elizabeth Spurr;[2] 'the roughing out of the two-and-a-half ton mahogany log took about 18 months'.[3] It received a great deal of publicity when it was unveiled in 1934 at the Tooth's Gallery, London. As the *Daily Sketch* reported, it was based on his own English thoroughbred mare Jenny: 'the pose shows the animal "passaging" before a race – that is, moving sideways, and ready to jump off. The idea was to get the most vitality with the least action, so the giant wood horse has all four feet on the ground.'[4]

In order to promote the show Skeaping gave an interview to the *Daily Mail*: 'Perhaps I ought to tell you that I have concealed something in the belly of my horse. It is a little bundle of papers containing my private and personal views and opinions about my contemporary artists and their work!' 'Posterity (if my horse survives) may get some fun out of what I have written. I hope it will, at any rate!'[5] Further publicity was published in a prophetic article in the *Scotsman*: 'Rossetti, you will remember buried his poems in the coffin of his wife and when his friend clamoured for publication they had to break open the grave. Some day perhaps when Skeaping's *The Horse* stands in the central court of a great museum – where else can it go – being wooden and so huge? – men will come and dismantle it to rescue the precious missive. Certainly this is

Fig.47 *The Horse* (1933) after conservation treatment, 186 × 386 × 57 cm, 375 kg. N06129

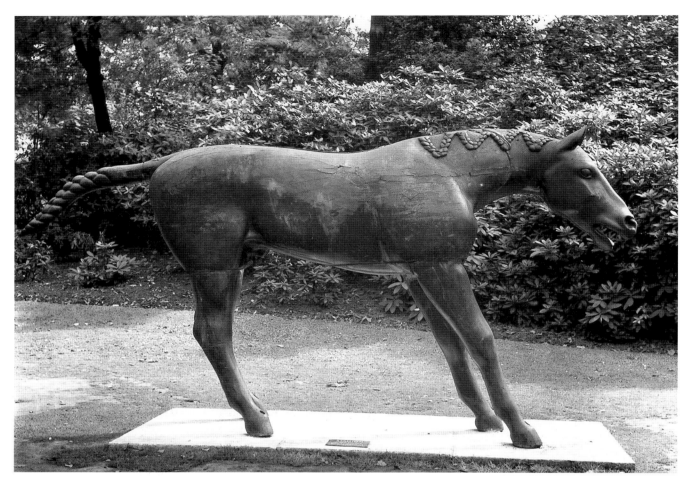

Fig.48 *The Horse* on display
at Whipsnade Zoo, 1937–45

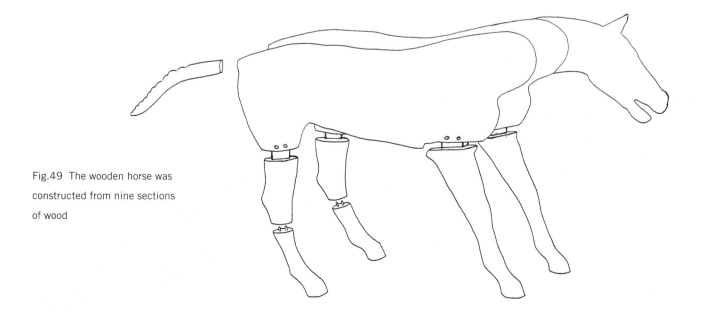

Fig.49 The wooden horse was
constructed from nine sections
of wood

the most entertaining sculptural stunt since Epstein's *Genesis*.'[6] (The paper found when the horse was dismantled is discussed below.) The sculpture was bought by Whipsnade Zoo and exhibited outside at the Zoo from 1937 to 1945 (fig.48). In 1945 the Zoological Society of London presented it to the Tate Gallery.

The wooden horse was constructed from nine sections of wood weighing a total of 375 kg (fig.49). The body was made from a mahogany log (*Khaya grandifoliola*) split along the grain; according to the artist he then 'cut the trunk in half length-wise, and hollowed it out with an adze and gouges'.[7] Hollowing out the body would have reduced the weight and stress within the wood structure, lessening the chances of warping and cracking. This is because the wood closest to the outer surface of the tree (sapwood) has a different structure from the centre of the tree (heartwood).

The body was split asymmetrically down the back and along the side of the neck with the head integral to the left side. This had the advantage of making the main join less noticeable. The legs were made from Pyinkado (*Xylia xylocarpa*), a Burmese Ironwood. Skeaping considered this a harder wood than mahogany and he thought it would therefore better support the body.[8] The front legs were carved from a single piece of wood and each of the hind legs was constructed from two pieces joined at the knee. The top of each leg had a large tenon block located into a mortise hole in the underside of the body and was secured with a total of ten dowels drilled at right angles. These dowels in time gave way, exerting pressure on the leg joints

and causing a pronounced backward lean. The carved plaited tail had an iron bracket that secured the tenoned end, with screws, to the horse's body (fig.50).

When *The Horse* came to the sculpture conservation studio, it was clear that the surface and structure had suffered considerably. While on display outdoors at Whipsnade Zoo it had been climbed on and defaced; dents plus painted and incised graffiti disfigured numerous parts of the body, legs and head. Weathering had given the surface an uneven bleached appearance. Skeaping probably originally gave the wood a final varnish finish which would have highlighted the naturally rich reddish/brown colour of the wood. Although he experimented with an unusual technique of colouring his sculptures using fresh blood,[9] there is no evidence that he used blood to colour *The Horse*.

Most of the original joints were probably not a very tight fit or had opened considerably during their prolonged stay outside. There was evidence of twisted brown paper and wood fillets used as packing either inserted by the artist or possibly part of a later repair. Movement in the wood had dislodged the filler exposing many small iron nails within the joints (used as anchors for the filler material). A fissure of up to 25 mm had opened between the two major body sections, exposing remains of previous

Fig.50 The carved plaited tail detached

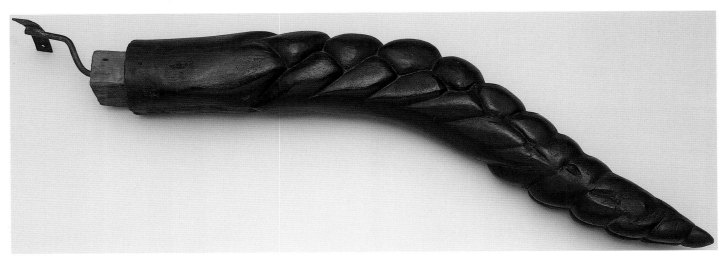

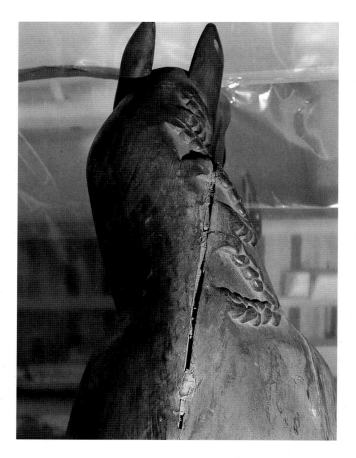

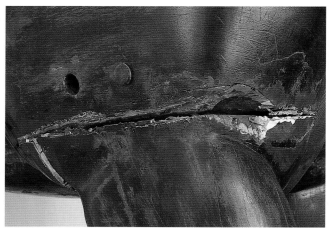

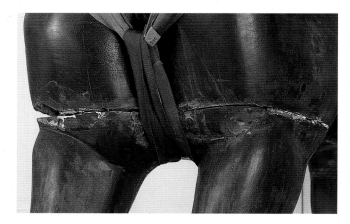

Fig.53 Considerable shrinkage and movement of the wood caused multiple cracking and separation of the jointed structure

(pre-Tate) restorations made of plaster, wood fillets and other coloured fillings (fig.51).

Exhibiting *The Horse* outside for more than eight years had caused water penetration which had led to fungal decay in the wood. This, along with a woodworm attack, resulted in a serious degradation of the wood structure, particularly along the upper edges of the leg joints (fig.52), while considerable shrinkage and movement of the wood caused multiple cracking and separation of the jointed structure (fig.53). To restore the sculpture properly, the massive body had to be completely dismantled.

The first phase of the restoration was to separate the wooden sections of the horse without causing further damage. The horse was laid on its side with the help of a block and tackle hoist. The ten dowels that secured the four leg tenons to the body section (fig.52) were withdrawn by inserting a headed screw in the centre of the dowel and easing it out with the help of a lever and mallet. Those that could not be removed easily were drilled out. Once the legs were removed, our next task was to separate the

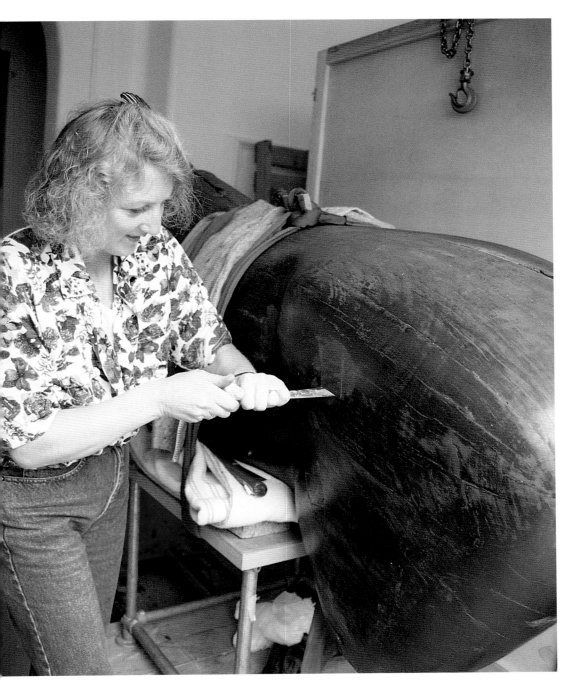

LEFT Fig.55 Conservator removing one of the square inserts

two body halves of the horse. The body was held together with five bolts, their ends countersunk and hidden behind ten square- and diamond-shaped inserts of wood set into the flanks (fig.54). The inserts were removed to reveal rusted bolt heads, washers and nuts (fig.55). As the rusted bolts were withdrawn with the help of easing oil, a hoist and ropes slung from a derrick were used to allow the two hollowed-out body halves to separate slowly.

... is practically my only opportuni-
ty of saying exactly what I think about
...ne.

...the truth, I am only interested
in ...self and my own pleasure ...
... that almost everyone I kn...
... the artistic world are just one mas...
... stupid...

... a very greatest genius ...
... painter has hardly got a ...
... idea in his head ...
... there are no other sculptors ...
... Epstein is one of the best ar...
... we have.
... Cedric ... is one of ...
... painters ...

There was some excitement about the prospect that the manuscript mentioned above might be found inside the horse. To our delight, a folded piece of yellowed writing paper clinging to the roughly gouged inner belly was found. This was part of the document deposited in the body cavity during construction. The paper had been folded twice with crumbled edges and was damaged by damp and insect attack. No other page or sheet of paper was found. On one side, handwritten in faded blue ink, there was a partly legible script (fig.56). In the following transcript the words or letters in brackets were indecipherable:

[…] is practically my only opportunit[y] []
[? sa]ying exactly what I think abou[t] [everyo]ne.
In truth I am only intereste[d] in
myself and my own pleasure.
[I] think that almost everyone I kno[w]
in the artistic world are just one ma[ss]
of stupidit[y]
[I] think Henry Moore is a g[…]
sculptor in a very limited way.
[Bar]bara Hepworth has hardly got a[n]
[? ori]ginal idea in her head.
There are no other sculptors ex[cept]
J Epstein is one of the best art[ists]
[…] we have.
Cedric Morris is one of the […]
painters
[…] and […] [? offend] [? nice] people I am […].

Skeaping was in a transitional phase of his career when he wrote this. His marriage to Barbara Hepworth had ended and he had drifted away from Hepworth and Moore as they moved towards abstraction.[10] If the artist was accurately describing what he put into the horse as 'a bundle of papers', then we could only assume that over the course of time the pages has probably dropped out through the wide splits in the belly. The paper was treated by paper conservators and is now in the Tate Gallery Archive. A photocopy transcript sealed in a Melinex envelope was put back in the belly of the horse.

With the horse's body in two halves, tool marks from an adze and gouge could be seen on the cavity's inner surface

Fig.57 Marks left by the adze and gouging chisel on the inside of the hollowed-out body

(fig.57). Areas of what looked to be inactive woodworm infestation in the leg joints were, as a precaution, treated with a liquid chemical insecticide. The deteriorated and weakened wood around the leg and neck joints were strengthened and consolidated with repeated injections of an acrylic resin in a solvent. A method was needed to rejoin the wood sections in keeping with the artist's original construction but using materials that would be more stable. The horse was reassembled by replacing the five rusted iron bolts that held the body together with stainless steel studding secured with hexagonal nuts and substantial washer plates.

The repaired legs needed to be reattached to the reassembled body (fig.58). In order to achieve greater strength, the existing dowel holes in the body section that held the legs in place were extended by drilling through the leg tenon to lock into the other side of the mortise hole. The original mortise holes were cut oversize by the sculptor with no keying surfaces for the tenons. On reassembling, to improve the joints' stability, layers of plyboard were used as packing in these hidden mortise holes. The repaired legs were pinned in place with new turned beech wood dowels, and the ends were capped with sections of the original mahogany dowel. When fully reassembled the horse was lifted again with block and tackle and stood back on its feet, and the detached tail was fitted back on to the body using the original metal bracket and tenon joint.

The large gaps in the joints were filled with wood fillets. Some areas of decayed wood were beyond saving and, in sections where structural strength was imperative, unsound wood had to be cut away and replaced with seasoned mahogany blocks and fillets glued in place. The replacement wood around the leg joints and along the centre back and belly of the horse was carved and sanded to match the original contours. The numerous small gaps remaining between the joints were filled with a mix of phenolic micro-balloons in a two-part epoxy resin. This produced a filler that was compatible with the original wood and was light, flexible, allowed movement of the wood and was easy to carve and paint.

This mixture was made up to a putty consistency which could be squeezed into the gaps with a workable time of at least twenty minutes. It was smoothed into position and,

when set, it was carved with a scalpel and sanded. All the body joints, incised graffiti and shakes in the wood were filled with this surface filler, and the fills were then skimmed with tinted Polyfilla before being retouched with acrylic paint.

There was evidence of several layers of varnish on the surface although much of it had been lost in the most weathered and exposed areas. In a cross-section viewed in ultraviolet light, five varnish layers were evident although some of these layers might have been the result of previ-

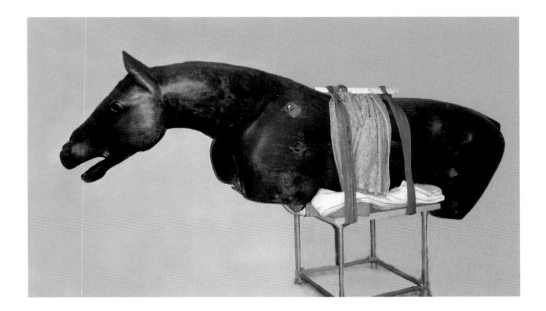

Fig.58 The body of the horse before the legs were reattached

ous restorations. It was decided not to remove any of the remaining varnish but to revive the original dark sheen in the bleached and damaged areas using a solvent-based wood stain. The surface was given a slight sheen with a final wax coating which gave a unified appearance but retained the aged patina of the wood.

The treatment took approximately four months to complete, ironically about the same amount of time it took Skeaping to carve the mahogany log. Once completed, *The Horse* was bolted to a permanent plinth through original holes in the hoofs and was displayed in the Tate's Duveen Gallery in 1994 with its legs firmly planted. To preserve the wood and its finish, *The Horse* will remain stabled indoors from now on.

Dr Joyce Townsend examined a varnish sample with optical and ultraviolet microscopy.

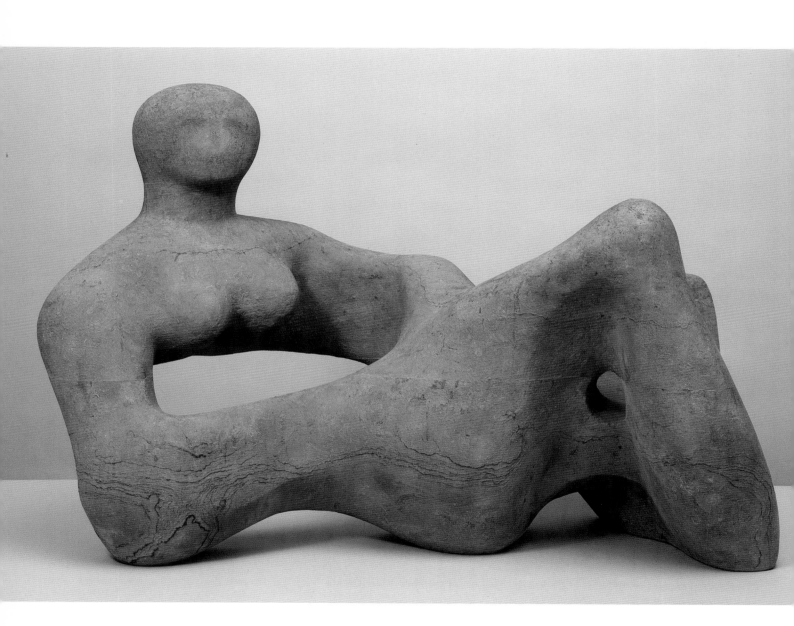

Recumbent Figure 1938

HENRY MOORE (1898–1986)

Tessa Jackson

A reclining figure by Henry Moore is instantly recognisable to thousands of gallery visitors throughout the world. Moore started carving these figures as early as 1929, ten years before *Recumbent Figure* (fig.59). He said of reclining figures: 'It always sounds like an understatement when I say that it's one of my favourite themes.'[1] *Recumbent Figure* was commissioned in 1938 by the architect Serge Chermayeff for the garden terrace of his new home in Sussex and was carved from green Hornton stone. In a talk given in 1955, Moore explained, 'I carved a reclining figure, intending it to be a kind of focal point of all the horizontals, and it was then that I became aware of the necessity of giving outdoor sculpture a far-seeing gaze. My figure looked out across a great sweep of the Downs, and her gaze gathered in the horizon. The sculpture had no specific relationship to the architecture. It had its own identity, it did not need to be on Chermayeff's terrace, but it, so to speak, enjoyed being there, and I think it introduced a humanising element; it became a mediator between modern home and ageless land.'[2]

Moore commented on the scale of the *Recumbent Figure*: 'This figure was made for a small terrace, but because the terrace is in the open air I made it over life-size; If it stood up, it would be a figure about 7ft high … I knew that the figure would be seen from the reception room and it seemed to me that in cold weather a nude – even an abstract one – might look incongruous to people looking out at her from a warm room. So I became absorbed by the problems of the draped figure.'[3]

Fig.59 *Recumbent Figure* (1938) after conservation treatment, 88.9 × 132.7 × 73.7 cm, 520 kg. N05387

In 1939, one year after the sculpture was finished, Chermayeff emigrated to Canada and the Contemporary Art Society bought the work and presented it to the Tate Gallery. Later that year the Tate lent the sculpture to an international exhibition at the New York World's Fair. In 1940, the Museum of Modern Art (MoMA) in New York was asked to store the sculpture over the war years. However, as Moore commented, 'it had a pretty tough experience when it was a war-time refugee in New York'.[4] In June 1944, while on display in the outdoor sculpture garden at MoMA, it was pushed off its pedestal. The letter describing the incident and addressed to the Director of the Tate, Rothenstein, played down the damage the

Fig.60 The sculpture knocked off its pedestal in the gardens of MoMA, 1944

Fig.61 Detail of the sculpture knocked off its pedestal at MoMA, 1944

sculpture had sustained, 'Fortunately the damage to the sculpture was less than might have been expected. The only serious damage was that the head was knocked off, as you will see from the enclosed photographs.'[5] The figure's right knee, however, was also damaged in this accident; figs.60 and 61 show how the sculpture landed on its head and knee. Mr Rothenstein then wrote to Henry Moore explaining that 'two ill-disposed persons'[6] had knocked the sculpture off its pedestal. *Recumbent Figure* was restored in New York before it was finally returned to London in 1946.

Moore was passionate about his materials and the concept of direct carving. In 1934 he said, 'Every material has its own individual qualities. It is only when the sculptor works direct, when there is an active relationship with his material that the material can take its part in the shaping of an idea.'[7] Moore used drawings to work out and store his ideas, after which he would experiment on maquettes. As he said, 'Sometimes I make ten or twenty maquettes for every one that I use in a large scale – the others may get rejected.'[8] The maquette made for *Recumbent Figure* was made in clay,[9] and later cast in an edition of twelve (nine bronze and three lead); it is the earliest known maquette Moore made for a large figure.[10]

Hornton stone was used by Moore for several major works, for example *Mother and Child* (1924, and 1943), the *Memorial Figure* (1945), and *Reclining Figure* (1946). Moore said, 'I made a point of using native materials because I thought that, being English, I should understand our stones. I discovered Hornton stone, from visiting the Geological Museum in South Kensington, which was next door to my college.'[11] Moore referred to it as 'a warm, friendly stone that I like using'.[12] He was so fond of Hornton stone that he requested it to be used for his tombstone which can be seen today in St Thomas's churchyard in Perry Green, Much Hadam, the village where he lived and worked for most of his life.

Hornton stone is named after the Oxfordshire village of Hornton, where it was originally quarried. It is Jurassic limestone (141–95 million years old) with coloured layers, which range from blue-grey to brown with a green tint; it is referred to in the trade as either green or brown. The colour of each stratum is related to the oxidation state of the iron minerals which run in veins across the layers.

Fig.62 Sample of Hornton stone showing brown and green layers

These iron bands and fossils are a characteristic feature of Hornton stone (fig.62). Due to the layering of the stone it can be quarried only in relatively small blocks, usually not larger than 2 m x 1 m x 20 cm. The green layer is the hardest part of the stone because it is the least affected by leaching and oxidation.

Before Moore started carving *Recumbent Figure*, three layers of Hornton stone were bonded to make a large block. This would have been done at Hornton Quarries where metal dowels may also have been inserted. The stone was bonded brown to brown strata and green to green thus avoiding a stripy effect (fig.64). Moore used traditional carving techniques; he described it as 'a straightforward process of having a hard material and knocking, carving or bursting pieces off'.[13] The quarry may have helped Moore by cutting parts off the block before he

Chisel

Point

Claw

Dummy mallet

Lump hammer

Fig.64 Illustration of joins
and strata layers

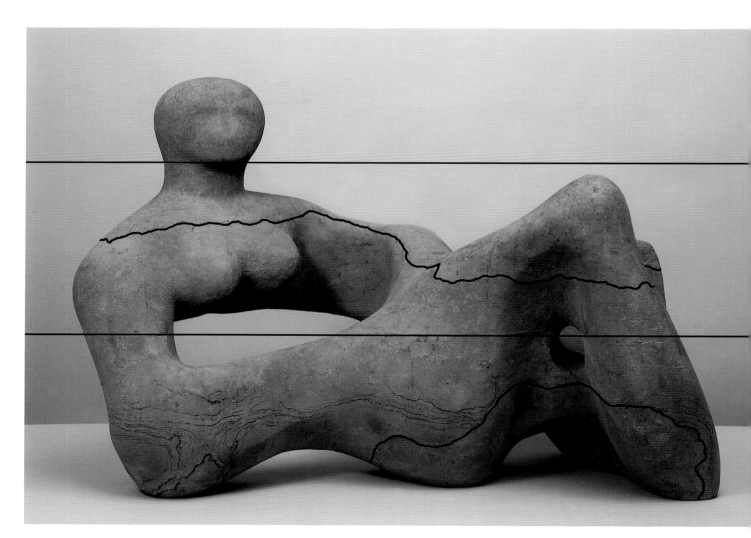

began the first stage of roughing-out. According to Bernard Meadows, who was Moore's assistant at the time, the work was intensive, and took five weeks to complete, working extremely long hours.[14] Pitcher and point chisels with a steel hammer were used to burst off the corners of the stone and create the general outline of the form. After this a mallet and claw tools were used followed by files and carborundum stone (fig.63).[15] The different densities between the harder green and softer brown stone made carving problematic at times. When fossils, iron veins, or softer brown stone were encountered within a hard area, some sections such as the right knee crumbled during carving and were restored by the artist and his assistant; the shape was never compromised, however.[16]

The two holes in the sculpture were carved by Moore and his assistant.[17] The pierced form was a recurring theme for Moore which he continued to explore throughout his life. The holes in *Recumbent Figure* did not weaken the sculpture structurally. Moore was well aware of this. As he said in 1937, 'A piece of stone can have a hole through it and not be weakened – if the hole is a studied size, shape and direction. On the principle of the arch, it can remain just as strong. The first hole made through a piece of stone is a revelation. The hole connects one side to the other, making it immediately three-dimensional. A hole can itself have as much shape – meaning as a solid mass.'[18]

The figure lost its smooth fine finish while on display outdoors in the sculpture garden at MoMA. Moore remarked upon its state in 1955 as being 'in a very weather worn condition owing to the extremes of heat and cold in New York, and its proximity to the sea'.[19] When the sculpture was examined in the conservation studio, the iron veins originally flush with the surface stood proud, creating a rough texture (fig.65). Viewed through a stereo microscope, many areas could be seen to be covered in a granular layer of iron oxide which had a similar appearance to brown sugar. Under magnification some areas that initially were thought to be damaged could be seen to be silt-filled gouges that had naturally occurred within the stone.

Although *Recumbent Figure* needed cleaning, the question was how much dirt should be removed. Some people grow

Fig.65 Detail of the iron bands, left elbow

BELOW Fig.66 The surface of the sculpture covered in paper pulp poultice

accustomed to the changes that have occurred with age and weathering, and consider the look to be appropriate as an 'aged patina'. For others, the effect is distracting and obscures their reading of the work. In this case, previous discoloured restorations were obtrusive, especially on the neck where the head had been rebonded, the inner section of the figure's right knee and the front calf section of the left leg (figs.67 and 73). The surface dirt and grease obscured the natural colouration of the stone which contrasted with the cleaner underside and protected areas. On the basis of this evidence and early photographs, it was decided to clean the surface dirt judiciously and to replace the old discoloured fills (fig.75).

Fig.67 Old restoration to figure's right
inner knee before conservation

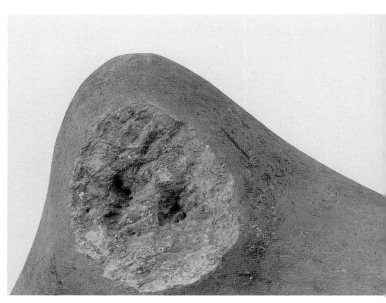

Fig.68 Detail of figure's right inner knee
after the old restoration had been removed

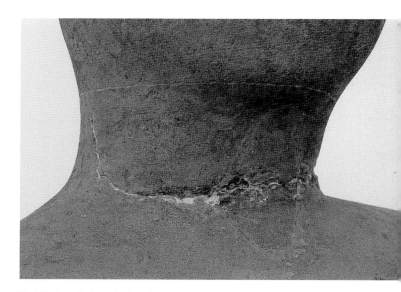

Fig.70 Detail of neck after the old restorations had been removed

Fig.69 Detail of knee after treatment

Fig.71 Details of neck after conservation

There are many different cleaning techniques used on stone and tests were carried out to find the most appropriate method for this work. Rather than using a mechanical technique that might leave the softer brown stone looking 'scrubbed' or unevenly cleaned, a poultice method was chosen. Several poultices were used to reduce the grime layers gradually; these were made from saturating blotting paper or pulverised paper pulp with varying quantities of pure soap and organic solvents (fig.66). The wet paper was stippled into the surface of the figure and left for about twenty-four hours. As the solvent and water evaporated, the dirt was drawn out of the stone into the paper – the same principle used as in a face-pack cleanser.

When early photographs were compared to the existing form, it was clear that the old restoration of the figure's inner right knee did not correspond to the original shape. The knee had been restored several times and although the current fill was a great improvement on the earlier restoration (fig.72), it was still slightly inaccurate and had subtly altered the character of the work. Both the curator and conservator agreed that the old restorations should be removed if this could be done without damaging the stone. The knee would then be reconstructed (fig.69) using photographs of the original form as a guide. Moore believed that form was the essence of what sculpture was about and that sculpture should be viewed from all sides: 'A sculptor is a person who is interested in the shape of things.'[20]

Having identified the old fill materials through analysis as stone dust and sand with a white glue binder and acrylic overpaint, a safe way was found to remove the old fills (figs.68, 70 and 74). A new filler was then needed that would be as close to the original stone in colour and texture as possible, yet be reversible in future if necessary. The most successful combination tested was a mixture of ground Hornton stone and aggregates in a binding medium. It was decided to use dilute acrylic emulsion as

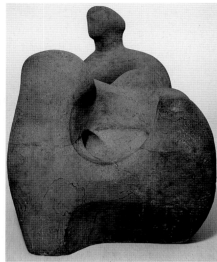

Fig.72 Undated photo of old restorations showing knee incorrectly shaped

Fig.73 Figure before treatment

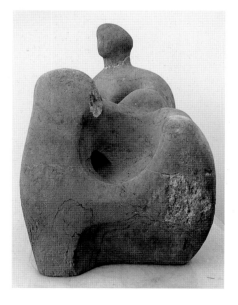

Fig.74 Mid-conservation, after removal of all old fills

OPPOSITE

Fig.75 Figure after conservation

the binding medium because it was easily reversible, did not stain the stone or darken the fill, and held the stone dust and aggregates together well.

To reconstruct the right knee and left shin, the area of stone that was to receive the new fill was lined with acid-free tissue. Adding a separating layer is a technique used in conservation to ensure that a restoration can be removed later, if necessary, without damaging the original. A separating layer is also useful for providing visual evidence of where the restoration starts. Often the fill is so closely matched to the original that the join is not easily detectable. Great care was taken not to overfill the original stone (figs.69 and 71) and highlights and texture were added to the fills by using a small drill and riffler files (fig.75).

Removing the surface dirt layers exposed the warm colouration and revealed the subtle tones of greens and browns of the stone. As Moore said in 1955 after seeing the weathered sculpture, 'At least I discovered that Hornton is not suitable for exposure in intemperate climates.'[21] In future the sculpture will remain on display indoors so that the fine quality of the surface will be protected.

Dr Tom Learner analysed the old fills with Py-GC-MS and FTIR.

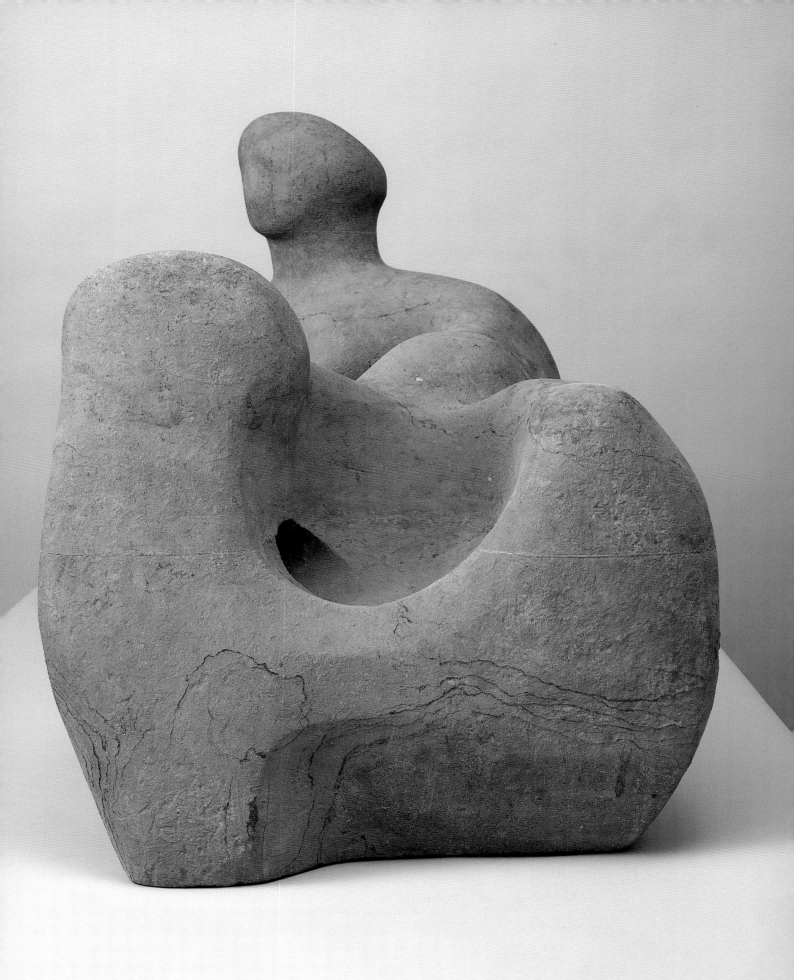

Chair 1969

ALLEN JONES (born 1937)

Lyndsey Morgan

Allen Jones is an important figure in the 1960s' British Pop Art movement, and has combined the influences of graphic style and popular culture in a set of three sculptures which have now become icons of the art produced at that time: *Chair* (fig.76), *Table* (1969) (fig.77) and *Hatstand* (1969) (fig.78). The sculptures were made in editions of six. All depict female figures, dressed in fetishist clothing, functioning as pieces of furniture.

Chair (number two of six) is owned by the Tate Gallery. It portrays a life-size female figure lying on her back with her knees resting against her chest. A leather cushion sits on the back of her thighs whilst her calves form the backrest for the chair. She is painted in a naturalistic skin tone and is dressed in leather hot pants, elbow-length leather gloves, and knee-length lace-up leather boots with high heels.

The sculpture has been controversial because of its erotic content since it was first displayed. The artist said that he was initially inspired to create this work when he travelled to Reno in America and saw slot machine units set into painted life-size figures of cowboys and showgirls. He liked the idea that he could easily engage with these figures because they looked realistic.[1] When questioned about the erotic nature of this trilogy of sculptures the artist commented that: 'Eroticism transcends cerebral barriers and demands a direct emotional response. Confronted with abstract statement people readily defer to an expert. It seems to me a democratic idea that art should

Fig.76 *Chair* (1969) after restoration, 77.5 × 57.1 × 99.1 cm. T03244

be accessible to everyone on some level and eroticism is one such level.'[2]

The idea behind these sculptures was that they should represent something perfect and mass-produced rather than an object produced by 'the hand of the artist'. Allen Jones made working drawings for the three figures and then commissioned Dik Beech, a freelance sculptor who worked for Gems Models, a company producing mannequins for shops and museums. Beech made the life-size

Fig.77 *Table* (1969)

OPPOSITE
Fig.78 *Hatstand* (1969)

original clay models under Jones's close supervision although the artist was not directly involved in casting or painting the sculpture.

A mould was taken from the original clay model, as with the more traditional technique of bronze casting. The mould retained the negative impression of the original and was used to cast a plaster replica, giving a robust surface for finishing.[3] The plaster figure was then used in order to make a second mould from which the edition of six sculptures was to be cast. These casts were made using polyester resin reinforced with glass fibre matting. Several thin layers of polyester resin were painted on the inside surface of the mould and sheets of glass fibre matting cloth were then added to give the resin strength and flexibility. More resin was then painted and poured over the cloth so that it could

become incorporated into the resin layer. This process was repeated until the desired thickness was reached; in the case of *Chair* this was between 3 and 5 mm. Once the resin had set, the mould was removed to reveal a strong and lightweight hollow figure.

The cast for *Chair* was reinforced with a resin mix around the areas where the Perspex seat is attached to the figure by means of bolts. This ensured that the finished sculpture could withstand the weight of a person sitting on it as the artist intended that all three of the sculptures in the series should be functional.

The cast resin was translucent and almost colourless at this stage, but a cellulose primer was sprayed on to it in several layers, each of which was carefully sanded down to provide a smooth base coat for the final layers of acrylic paint. All the sculptures in this series were then hand-painted, each one slightly differently, by Lucina Della Rocca, another freelance artist who had worked with Allen Jones on earlier theatrical projects.

The clothing and cushion for *Chair* is fabricated from black leather and was custom-made with the exception of the gloves. The hot pants were made by the designer who made leather garments for *The Avengers* TV series and for the James Bond films. The boots were made by Annello and Davide who make theatrical and ballet footwear, and the fashion designer Zandra Rhodes designed clothing for the other figures in the series.[4] The wig and false eyelashes are synthetic fibre and the features on the face were all painted with particular attention given to the eyes and lips. The body was painted with broad brushstrokes using artists' acrylic paint.

The sculpture was vandalised whilst on display at the Tate Gallery in 1986. The attack took place in 'women's week' and although the attacker was not caught it was assumed that this was a feminist protest. Two bottles of a viscous paint stripper were thrown at the sculpture and landed in a number of areas around the face and neck with dramatic effect. The acrylic painted surface wrinkled and faded leaving the polyester resin underneath exposed (fig.79). About 30 per cent of the visible surface was damaged.

Soon after the attack the swollen and discoloured paint affected by the paint stripper was skinned away to allow the layers underneath to be repaired. This revealed that

Fig.79 Damage to the face

Fig.80 The damaged paint
layer has been removed,
revealing the cellulose paint
layer beneath

much of the polyester resin in this area had been swollen and pitted and that the cellulose undercoat was flaking wherever the paint stripper had been in contact with it (figs.80, 81 and 82). The remaining paint surface was generally undamaged but during its time on display exposed areas of paint had acquired a layer of dirt which seemed to have become partially embedded in the acrylic paint surface giving it a grey and patchy appearance. Paint underneath the boots and gloves was a brighter colour than on the exposed flesh which suggested that the paint had faded with exposure to light. Splashes of dried paint stripper were visible on the boots, gloves, cushion and on the false eyelashes (fig.83). The clothing was removed from the sculpture immediately after the attack so that the worst residues of the paint stripper could be cleaned from the leather surface and the sculpture was then moved to the sculpture conservation section to assess the damage.[5]

At this stage it was very fortunate that the artist and many of the other people who had been involved in cre-

ABOVE Fig.81 Detail
of the damage

RIGHT Fig.82 The damaged
paint beneath the eye

Fig.83 Paint stripper residue
on the boots following the attack

ating this work were able to give us important information about their techniques and intentions. This information was enhanced by the use of chemical analysis. Most of the questions surrounding *Chair* concerned the composition of the paint layer. Several samples were taken from unobtrusive areas of the painted surface, all of them no bigger than a pin head. Cross-sections of these samples were examined to show the different layers which make up the surface and the pigment particles contained within them. It was also possible to discover something about painting technique from these sections. Although it looked as if the figure had been painted a uniform pink colour, the painted surface was actually made up of a number of different shades of pink which had been applied in thin layers, sometimes blending in with previous layers not yet dry. Tiny particles of various pigments were also visible and helped confirm pigment types. Light had faded some of the red pigments in the flesh colour which would explain why the paint underneath the boots, hot pants and gloves appeared to be brighter (figs.84 and 85). The paint was identified as an acrylic emulsion.

The pitted areas caused by the paint stripper solvents on the upper half of the body and face were filled using a polyester resin obtained from the Gems Models company which was as close as possible to the original resin used. These fills were coloured so that the restoration could be detected in the future, and were then sanded down to give a smooth surface for painting. As has been stressed throughout this book, it is a fundamental principle in conservation that any material added to a work should be distinguishable from the original and, if necessary, removable at a later date.

Choosing a method for cleaning the undamaged paint surface was complicated by the fact that the acrylic paint was highly sensitive to most solvents. Water and white spirit were the exceptions, but these were not always successful in cleaning away the more ingrained dirt. A plastic eraser was therefore used to pick up very gently the more embedded dirt to give a more accurate basis for colour matching during restoration.

At this point the artist was consulted and asked for his opinion about the progress of the restoration. From a

conservation point of view, we were keen to keep as much of the original paint layer as possible and to restore the damaged areas so that they fully blended in with the original paint. One of the problems with a restoration of this kind is the possibility that the new restoration might become obvious as it ages or fades at a different rate from the original paint. The artist was particularly concerned about this problem, as he felt that it would affect the concept of the work as a perfect, mass-produced object.

It was therefore necessary to use a technique that would enable us to retouch only the missing areas but at the same time make it possible to remove the restoration completely and rematch the colours if a colour change took place. The artist agreed that the restoration could go ahead provided that this could be achieved.

Acrylic paints were considered for the restoration in order to achieve a texture and sheen which would match the original. The problem with this approach was the possibility that the restoration could become indistinguishable from the original acrylic paint in some areas. It would then be impossible to remove restored areas at a later date without damaging the original paint layer which would make the treatment unacceptable.

The solution to the problem was to use a thin layer of resin varnish which would be applied over the boundaries of the damaged area to act as a separating layer between the original painted surface and the acrylic paint to be used in the restoration. This would ensure that the restored areas could be removed if necessary without affecting the original paint. This technique is commonly used in the conservation of objects and is referred to as applying an 'isolating layer'. It would rely on our finding a resin which was soluble in white spirit as this was the only solvent which did not affect the acrylic paint. It would also be necessary to confirm that the paint used for the restoration could be removed from the surface of the resin intervention layer, without damaging the underlying original paint. A number of resins were tested for suitability. Finally, a resin more frequently used in the conservation of paintings was found which fulfilled all these requirements. The restoration could now go ahead.

A great deal needed to be done to restore the face where the painted eyes had been badly damaged by the paint

Fig.84 Paint section of original paint viewed under × 250 magnification showing the brown cellulose paint (bottom), white undercoat (centre) and flesh-coloured acrylic paint (top)

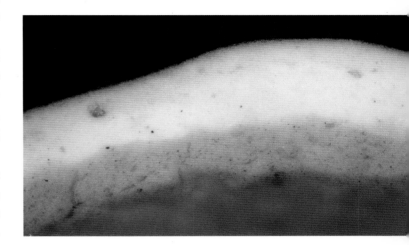

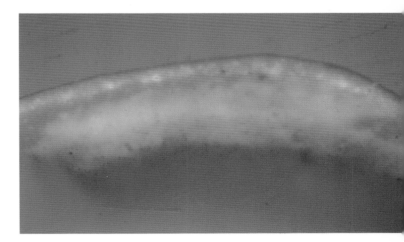

Fig.85 The same paint section viewed under UV light showing how red pigment particles do not appear in the top part of the flesh-coloured layer because of fading

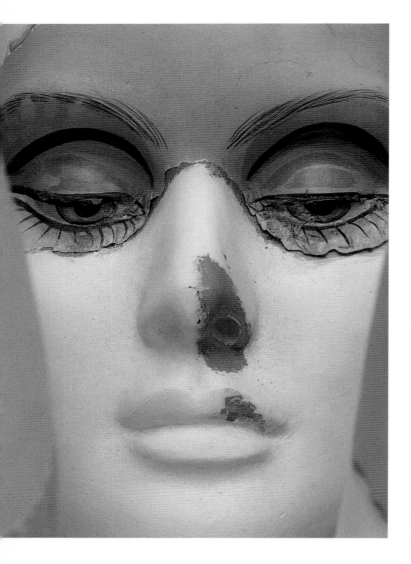

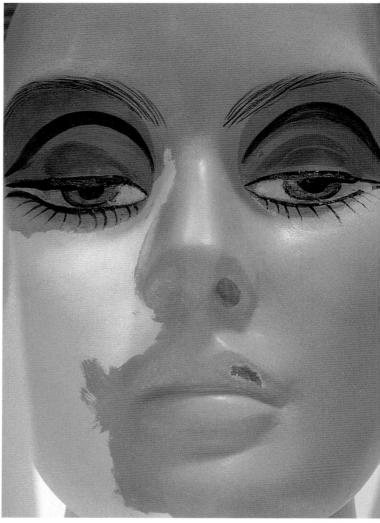

stripper solvent. Here, the details of the lower areas of both eyes had been badly discoloured and distorted and the solvent had leached out the organic red pigment causing the skin tone on the face to fade from pale pink to pale yellow. The wrinkled paint had stuck to itself and was lifting away from the surface.

The aim here was to lay the paint back on to the surface of the sculpture and then to retouch the yellowed areas if possible. Because the underlying surface had also been badly pitted the first step was to build this area up once more to obtain a smooth surface on which to lay the lifted paint. This was achieved using successive layers of a thick acrylic paint almost like a gesso, sanding down the layers between each application to build up the shape of the lower eyelid. Restoring the damaged paint film to its

original position involved working under a binocular microscope to peel apart the areas which had stuck together, carefully using a small amount of water to soften the paint film. Finally, a water-soluble adhesive was then used to adhere the paint film smoothly back on to the surface.

The problem of tinting in the discoloured paint was tackled by applying the resin varnish over the entire damaged area and allowing it to dry to a shiny film. It was then possible to colour-match the original paint using a modern acrylic paint over the top of the resin varnish layer. The same technique was used on the lips where only a very small island of original colour remained. A colour match was reached using both the remains of the paint and photographs for reference (figs.86, 87 and 88).

OPPOSITE LEFT Fig.86 The first stage of
the restoration. The pitted areas of the face
have been filled to a smooth surface and
a layer of white undercoat applied

OPPOSITE RIGHT Fig.87 The wrinkled paint
under the eyes has been softened and
readhered to the surface. On the right
of this photograph a separating layer of
resin has been applied before retouching
with acrylic paint

ABOVE Fig.88 The restored face

The paint stripper residue on the leather clothing was carefully peeled away and the remaining traces removed with de-ionised water on cotton wool swabs. A small amount of microcrystalline wax containing black pigment was applied to the damaged areas to feed the leather and restore colour and surface shine. The eyelashes, which had been badly clogged with the residue, were carefully cleaned in the same manner which restored them to their original shape.

A photograph of the sculpture, taken when it was first made, showed that the wig had lost a great deal of its original shape over time. We decided to restyle the wig with soft foam rollers so that it more closely resembled the earlier photographs. Basic polymer tests on the hair showed that the wig was fabricated from synthetic fibres. It was therefore necessary to avoid solvents and heat in the styling process as these can damage synthetic materials and speed up their degradation.

Finally, conversations with the artist revealed that he had originally intended the work to be displayed on a sheepskin rug although the sculpture did not have a rug when the Tate Gallery acquired it. The artist explained that the idea was to disguise the rather stiff appearance of a mannequin where it touches a flat surface so that the figure was 'grounded' and appeared more realistic. The curators agreed that a replacement rug could be purchased and the work will be displayed with it in future (fig.76).

The extent of the damage on this sculpture made it necessary to carry out a more radical restoration than is usual, although the use of an intervention layer should ensure that the restoration is reversible in future. We were fortunate that the artist was available to discuss the project. This, together with good colour photographs of the work prior to the damage, enabled the restoration to be carried out with technical accuracy whilst keeping the artist's original intention in mind. The treatment took three months to complete and has enabled the sculpture to be displayed in the gallery again, although it is now displayed behind a barrier for protection and the lighting is controlled to reduce fading.

Dr Joyce Townsend analysed the pigments using EDX and optical microscopy and Dr Tom Learner used Py-GC-MS to identify the paint medium.

8

Natural Selection 1981

ANTONY GORMLEY (born 1950)

Sandra Deighton and Jackie Heuman

Antony Gormley's early work *Natural Selection* developed out of his commitment to defining the relationships that exist between people, objects and nature. Conceived towards the end of 1979, completed in 1981, and bought by the Tate Gallery in 1983, it consists of twenty-four objects, half of which are man-made and half natural. They are arranged in ascending size, the manufactured objects alternating with natural ones. Each object is enclosed in an individually moulded lead casing. The artist started with the idea of something small and organic progressing to the larger and artificial: the first object in the sequence is a pea, the last and largest a ball. While many of these objects were readily available, others took Gormley months to find. He started collecting the objects by shape: 'I became tickled about the relationship between the objects.'[1] He regards this piece as an 'analytical work that explores the objective world', and his intention is that it should invite speculation and provide an 'open ground for experience and reflection' for the viewer to make connections between the forms.[2]

The contents of the lead shells in order of display are: pea, pencil, carrot, cold chisel, banana, vibrator, courgette, bradawl, cucumber, plumb bob, goose egg, grenade, lemon, light bulb, pear, paintbrush, parsnip, pestle, marrow, bottle, coconut, ball of string, melon and ball (fig.89). It was important to the artist that each real object should be inside its lead casings: 'The surface carries the memory of a moment in the history of the object.'[3] As J. Lomax has

Fig.89 *Natural Selection* (1981) – individual pieces after conservation treatment



83

commented, 'All the work is about what isn't there, something that can be held in the mind but is absent from view, either it has been concealed or it has been removed.'[4]

Gormley retains an active interest in his work and has been involved with the display and restoration of this piece since the Tate acquired it. It has been exhibited directly on the floor arranged diagonally across the room rather than parallel to the walls; recently in Japan the artist enclosed it in a large display case. The work is always laid out in the

selection and are a mix of natural and distressingly unnatural inventions'.[5] The artist is intrigued by the relationships between the objects themselves, their forms and sizes, as well as the incongruity between the lead cases and their contents. Referring to *Natural Selection*, Gormley has described how 'the dialectic I have used in opposing cultural and natural objects and trying to reconcile their differences whilst at the same time underlining them, relates to the closeness of creativity to aggression, of

order given above in a 12 m long straight line, with equal space between the component elements (fig.90). The largest pieces point towards the pea until the bradawl, then the smaller pieces point away. The intention is to give a sense of progression and direction that pulls the observer forward.

For such a seemingly simple work, *Natural Selection* has a multiplicity of associations. The title is an obvious reference to Darwin's theory of evolution but it is intended to be ironic. The objects included 'are a very unnatural

sexuality and destruction. In *Natural Selection*, those two dialectics are very implicit. By alternating a man-made object with a god-made object I also uncover a sexual division – objects of aggression are naturally phallic: objects which present a containing oval are naturally female.'[6]

Although lead has become a significant art material in the last generation, used by artists such as Beuys, Maillol and Kounellis, no other artist has used it as consistently as Gormley. There is little doubt about the proficiency with which Gormley manipulates this uniquely soft metal, and he

is clearly passionate about his choice of lead: 'I feel it is the best possible material and I love it! … It's the most female metal, it's the most malleable and the densest metal. It has the capability of taking on a form and also holding it; it's completely impenetrable visually, radioactively.'[7] Gormley has said that he chose lead for the same reason as Maillol did for his nudes: he wanted to have a tension between the sensuality of the form and the distancing effect of the material.[8]

This link between material and form is of paramount

importance to Gormley. The first stage in making this work was to make plaster casts of the soft objects such as the vegetables, fruits and egg. The pencil lines on the plaster casts (fig.91) indicate the artist's careful planning of the next stage. Pieces of roofing lead, 2 mm thick, were cut and then contoured against the plaster cast or, where possible, the real object such as the hand grenade and paintbrush, by gently beating with a rubber hammer. Most of the lead casings are made with either two or four pieces of lead with butt joints. The original object was sealed inside the casing

by soldering the seams with flux and lead solder. These horizontal and vertical seams were left slightly proud and visible giving the viewer a glimpse into the sculptor's process. Although lead has a lustrous silver-blue appearance when freshly cut, it darkens on exposure to air forming a protective layer. The artist liked this appearance and did not apply any artificial patination to the finished lead; he preferred the lead to look worn and natural. He refers to it as 'so dense, that its greyness combines all colours'.[9]

Soon after the sculpture was acquired, problems were noticed on the lead casings containing the banana, courgette, lemon, pea, parsnip and melon. The contents were decomposing and leaking, causing white disfiguring marks on the outside of the casings. At this time the Tate Gallery did not have a sculpture conservation section and these pieces were returned to the artist for treatment. He unsoldered the lead seams and removed the contents from their casings. He dried the fruits and vegetables before replacing them and resoldered the lead.

In 1983 the goose egg was identified as the source of a pungent, unpleasant odour. The egg represents one of the central elements in *Natural Selection* along with the grenade; representing the dialectic of destruction and creation, 'an object associated with aggression (grenade) is morphologically close to an object naturally associated with creativity (egg)'.[10] The casing containing the egg was made from four pieces of lead soldered vertically. With the artist's permission, in the newly established sculpture conservation studio, the casing was opened along two seams with a fine bladed saw on a dental drill. The casing was cut in half along existing solder lines with minimum loss of material (fig.92). As expected, the egg was decomposing and had a very foul hydrogen sulphide smell. The eggshell was broken in many pieces but was held in position by the internal membrane (fig.93). The contents were removed and soaked for one hour in an alkaline solution to dissolve and soften the organic matter. The shell fragments were rinsed until the wash water was a neutral pH, dried and then reassembled and glued into position. The goose egg was replaced in the casing in keeping with the artist's wishes, and the two halves of the casings were resoldered back together.

Part of the difficulty in checking the condition of these objects is that it is impossible to know what is happening

Fig.92 The egg lead casing was opened along the existing solder lines with minimum loss of material

Fig.93 The eggshell was broken in many pieces but was held in position by the internal membrane

inside the lead casing. Since lead absorbs radiation, a quality Gormley particularly likes, x-radiography cannot be used as a diagnostic tool. Any changes inside the casing cannot be detected until there is some alteration on the outside of the lead. Thus photographic documentation of each individual piece is therefore essential for condition checking.

In 1996, the sculpture was checked before being loaned to a Gormley touring exhibition in Japan. Most of the objects were in good condition but the lead encasing the coconut was seriously corroding. The fresh coconut had been enclosed for fifteen years and the flesh and milk had decomposed yielding organic acids which ate through the lead casing and dribbled over the outside creating thin white streaks and isolated patches of surface corrosion (fig.94). The lead had ruptured in places fracturing some of the soldered seams and there were many small holes with raised brown edges of crusty corrosion. It was apparent that if this process were allowed to continue, the lead object could eventually corrode completely.

The first step was to remove the coconut from its soldered lead casing and assess the problem. There was some concern about health risks because harmful products from the decomposing food and lead might be contained in the casings. Specialists at the Natural History and Science Museums assured us that there was no health risk from food poisoning such as botulism or poisonous lead compounds if normal safety precautions were taken (wearing suitable masks, gloves and goggles for instance).

There was sufficient solder between the four pieces of lead that made up the casing sections to saw through with a small piercing saw without touching the lead either side. To our surprise, a very thick white and brown crusty layer filled the void between the coconut shell and the inside of the lead casing. It looked like plaster but was identified as a lead corrosion product. Lead is susceptible to change when in contact with mild acidic products and, in this case, the reaction with lead of the acidic by-products from the decomposing coconut formed a basic lead carbonate. The flattened fibres on the coconut husk had encrusted particles of lead carbonate and in places there was black mould.

The coconut was removed from the lead casing in a fume cupboard and sealed in cling film to protect the conservator from mould spores. But since it was important

Fig.94 Corrosion on the lead casing as a result of organic acids leaking out from the decomposing coconut

ABOVE Fig.95 The coconut shell was reinforced with strips of plaster of Paris bandage to form a strong support structure allowing the shell to be sawn in half

RIGHT Fig.96 The cleaned coconut

to retain the original object inside the casing, the coconut itself needed to be treated. It was opened to remove any soft organic matter which might have continued to decompose causing further corrosion. Since sawing risked shattering the coconut shell, it was wrapped in cling film which was then reinforced with strips of plaster of paris bandage. When dry this formed a strong support structure allowing the shell to be easily and accurately sawn in half using a band saw (fig.95). The cut across the coconut was made at 90 degrees to the cut in the lead casing to allow for ease of reassembly.

The flesh was removed with a scalpel and the cleaned coconut shell was ready to be replaced back inside the lead (fig.96). The disfiguring white corrosion that had formed on the outside of the lead casing was softened with a chelating solution and rinsed. The softened corrosion was then mechanically removed. Holes in the lead formed by the corrosive effect of the coconut milk were filled from the inside with polyester resin coloured to match the lead with graphite and pigments. Finally, the coconut was replaced in its original position and the lead seams resoldered with a conventional soldering iron (fig.97).

Gormley is content with how the work has aged,[11] although he agrees that in future any decomposing food will need to be treated to prevent the lead from corroding. Thus preventative conservation, including proper storage, is important to help preserve the work. If stored in a wooden crate, the organic acids emitted from the wood could corrode the lead. Therefore, the lead pieces are stored in a sealed aluminium foil bag with conditioned silica gel to keep them dry but routine condition checking is necessary to monitor changes. Gormley is still very fond of this piece. As he reflects, 'What you know and what you see continue to activate this work.'[12] For Gormley 'art is always for the future'.[13]

Fig.97 The lead casing after treatment

The lead corrosion product was identified by XRD carried out by David Thickett of the British Museum and Dr Joyce Townsend of the Tate Gallery.

OTTOshaft 1992

MATTHEW BARNEY (born 1967)

Jackie Heuman

The overwhelming impression of the installation sculpture by Matthew Barney, *OTTOshaft* (fig.98), is of its unconventional materials and complexity. Barney is a very inventive craftsman: the sculpture is made up of organic and synthetic materials such as tapioca, bread, meringue, Vaseline, silicone rubber, vinyl, clothes and three continuously running videos.

Born in San Francisco in 1967, Barney lives and works in New York. His work is deeply personal and he explores a strange and complex mythology through metaphorical narratives. Barney gathers together elements from different sources that have a specific meaning for him, and extracts from each a theme that contributes to his narrative. *OTTOshaft* offers an 'insider's view of the gallery-stadium, exposing its internal organs, locker room, and training paraphernalia'.[1]

Barney began working on *OTTOshaft* in 1992; it is one of a trilogy of works called the Jim Otto Suite. While fully self-contained, *OTTOshaft* is the middle section in the trilogy. It is divided into two parts, or 'suites'; one suite is named after a legendary American football coach, Jim Otto, the other after the 1950s' screen actress Jayne Mansfield. According to the artist the suites represent contrasting physical conditions, and the sculpture has been described as 'a singular installation of peculiar, dynamic elegance that is as perplexing as it is mesmerising'.[2] It was originally exhibited under the curving exit and entry

Fig.98 *OTTOshaft* (1992), mixed media, variable size. T06964

Fig.99 Jim Otto Suite
(Tate Gallery 1995)

ramps of an underground car park in Kassel, Germany,
during Documenta, the international exhibition of con-
temporary art that takes place there every five years.

The sculpture was presented to the Tate Gallery by the
Patrons of New Art in 1994 and was first exhibited in
1995 and adapted by the artist to be shown in a single
space. An ascending wall divided the two suites and white
vinyl cloth lined the floor and walls (figs.99 and 100) as
visitors followed a curving path around the work.

Most of the viewers were unable to recognise that the
largest element, weighing 375 kg and measuring 4 m × 2 m
was made from tapioca. In any case, the tapioca available
in Britain looks quite different from the kind commonly
found in America that Barney used. Artists such as Dieter
Roth and Joseph Beuys have used food in artworks over
the last few decades, and its natural degradation is com-
monly linked to the artist's intention. However, Barney did

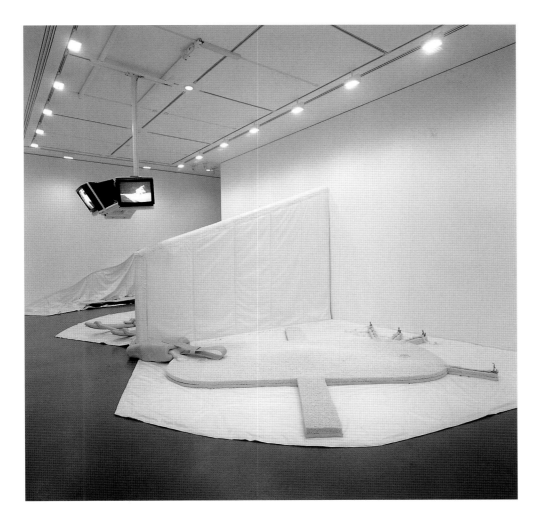

Fig.100 Jayne Mansfield Suite
(Tate Gallery 1995)

not choose tapioca because of its ephemeral nature; on the contrary he made it more durable by mixing it with epoxy resin. When it comes to preservation in a museum context, there is little precedent for the treatment of non-traditional materials such as tapioca. Therefore the artist's views and involvement are invaluable as a guide. This chapter considers the decisions that led to the remaking of the tapioca 'bed' and documents the techniques used.

Tapioca is made from cassava, a tropical plant with starchy roots. It is processed as beads in various sizes. Barney is very particular about his choice of materials and the tapioca was no exception. He chose a 5 mm 'fish-eye' tapioca: a regular-shaped round bead imported from Brazil. Making the tapioca bed was an ambitious undertaking in which his assistant helped the artist; it contains a steel armature prepared by a welder. About 200 kg of raw tapioca was mixed with a commercially available epoxy

resin and cast to a thickness of 100 mm on an oval-shaped foam wrestling mat. The thousands of tapioca beads have a silky sheen appearance and resemble a bed of pearls.

When *OTTOshaft* was installed at the Tate the tapioca was structurally in good condition although adhesive used to repair a previous minor break had yellowed (fig.101). *OTTOshaft* was subsequently displayed at a touring exhibition in Europe, and while on display at this second venue, the tapioca began to show signs of stress cracking; gallery

Although tapioca has a different chemical structure from wood, the comparisons between the two materials are useful in helping to understand what might have happened. Most kinds of wood have water 'bound' into their cells. If the wood is put in a higher relative humidity, it absorbs moisture and swells; conversely in lower humidities it looses water and shrinks. Tests showed that the percentage of water by weight in the resin-coated tapioca was similar to that of wood. We also discovered that the

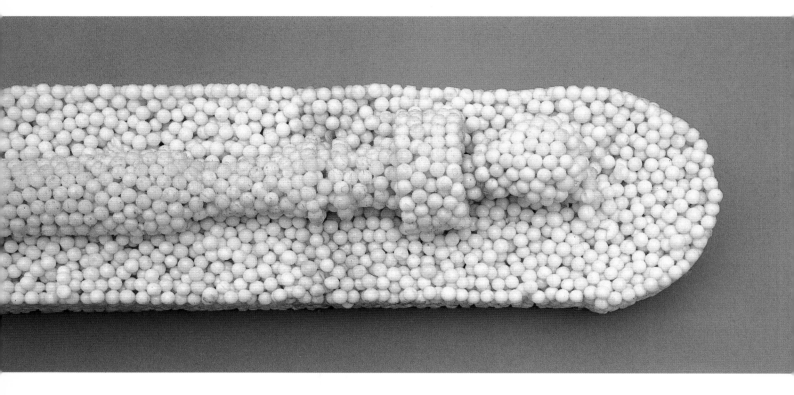

warders could actually hear the tapioca snapping. This was quite alarming as the cause was unknown. When the work was examined on site we were surprised to find that the edges of the main floor piece had dramatically cradled up off the underlying mat by approximately 3 cm at both ends causing two major cracks. The tapioca was monitored in a stable relative humidity and temperature for fifteen months. To our further surprise, the cradled tapioca began to lie flat on the underlying mat but the cracks were so severe that it was impossible to restore the form. Before considering the options available to us however, it was important to understand why the movement was occurring. As expected, no conservation literature on tapioca could be found.

raw tapioca held about 15 per cent more water than the coated tapioca. But how was this significant? The tapioca was originally hand-mixed with epoxy resin in large containers. This method of mixing may have caused an uneven coating of the tapioca beads allowing some beads to lose or gain moisture more rapidly than others, thus setting up internal stresses. Alternate shrinkage and swelling were probably what caused the cracking.

Fortunately it was possible for the curator and conservator to discuss the problem with the artist. Although the cracks could be cosmetically disguised, the work was structurally too weak to withstand handling. Barney felt it important to remake the tapioca so that in

future it could be displayed as originally intended. The fact that he wanted to remake the tapioca five years after its completion demonstrates his continuing interest in the condition of his work. With many contemporary sculptures, the artist's concept is as important as the materials, and thus the conservator has to strike a balance between conserving the materials and keeping faith with the artist's concept. In this case, the conservator, curator and artist shared the view that a copy was the appropriate

OPPOSITE Fig.101 Detail showing yellowed adhesive from a previous repair

ABOVE Fig.102 Preparation of the mould by protecting the wrestling mat with polythene sheeting. The plastic wall around the mat, which forms the mould into which the tapioca will be poured, can also be seen

solution and in 1997 the artist remade the tapioca with the help of his assistant and conservators at the Tate.

Just as Barney's work has been described as 'visually and imaginatively stunning but hard to fathom',[3] it is very difficult as a viewer to figure out how the tapioca floor was made. If the work survives into the next generation, it is hoped that the information documented below will be a valuable guide in helping future conservators care for this work. The detailed account of how the tapioca bed was remade may also give art historians an insight into the artist's original intentions, which come into focus through his personal involvement in the process.

Before the artist arrived in London, we gathered all the

necessary materials. This included importing from America the right type of tapioca and commissioning a new lighter aluminium armature to be made. Fig.102 shows the wrestling mat protected with polythene sheeting. The plastic wall around the mat, which forms the mould into which the tapioca will be poured, can also be seen. Once the mould was in place, the metal armature was laid in the middle of the mat. Barney was now ready to begin mixing the tapioca and resin.

Barney was interested in improving the materials and techniques used and readily accepted the suggestion to use a conservation grade epoxy that would reduce the chances of the resin yellowing with age. A filler was added to the resin and the correct balance calculated so that it had the consistency of honey and evenly coated the tapioca beads without sinking to the bottom. The mixing was done swiftly in small batches as the epoxy had a limited working time before it set. We purchased an ordinary electric cement-mixer to mix the tapioca and resin (fig.103). This was a great improvement over mixing by hand as it allowed the beads to be evenly coated in just a minute and the tapioca was then poured quickly avoiding any danger of the resin beginning to set at different times.

Barney developed the sculpture in stages. The first sections to be cast were the side extensions and bagpipe drones. Bagpipes appear repeatedly in the installation as a prop and a metaphor for processes that occur within the body. The drones were moulded in silicone rubber with a fibreglass mother mould and cast in tapioca (fig.104).

ABOVE LEFT Fig.103 The tapioca and epoxy resin in the cement mixer

ABOVE Fig.104 Barney working on a drone in its mould

BELOW Fig.105 Barney's assistant, Matt Ryle, inserting a speculum into the drone

Barney devised an ingenious method, in which the drones and side extensions appear to attach to the main body, thus diverting our attention from the fact that they were separately moulded. The joins are concealed with beads of loose tapioca.

Perhaps Barney's brief pre-med. studies prompted his use of the speculum, a medical device for vaginal and rectal internal examination. He was meticulous about cleaning and extracting the original specula from the old drones before inserting them into the new ones (fig.105).

LEFT Fig.106 Smooth-sided tins were used to form the holes at either end of the tapioca bed

RIGHT Fig.107 Barney's assistant filling the spaces between the bars of the armature with the wet tapioca mix

The sides of the tapioca and drone holders have the straight-edge quality, characteristic of a mould cast, which contrasts with the complex detailing of the drones. The delicate tapioca ball-shaped elements adhered to the top of the specula were made by transforming a small rubber enema bag into a mould. Barney slit the rubber down one side, filled the interior of the bag with the tapioca–epoxy mix and removed it when set.

Barney's use of tapioca represents the intake of carbohydrates by athletes for 'bulking up'. Another recurring image in the installation is a double zero, an unusual number that derives from an American football shirt. Barney's allusions to American football come from his student days playing for the Yale football team and from the pre-eminent role of the sport in the American public imagination. '00' is the number on the shirt worn by Jim Otto, a celebrated player and the subject of this work. For Barney these numbers also represent 'the orifice and its closure, the body and its self-imposed restraint'.[4] 'This body metaphor could be interpreted as two orifices at either end of internal passages in the body. An example is the link between the mouth and rectum. Nutrients are ingested through the one and are processed, via the digestive tract, to the other. A sphincter muscle in the anus tightens or relaxes to control the process of excretion – Barney's notion of closure and self-imposed restraint.'[5] A double circle is also present on the tapioca in the form of two holes (75 mm diameter), one at each end of the tapioca bed. They provide access to the interior of the tapioca, suggesting a relationship between positive and negative spaces, and between internal passages and access points on the surface.

Smooth-sided soup tins were used as fig.106 illustrates, to form these holes. The first layer of tapioca (three batches) was applied using trowels. Barney and his assistant filled the spaces between the bars of the armature with the wet tapioca and left it to dry a few hours (fig.107). The tapioca could be manipulated when wet, like clay, a quality Barney enjoyed. The second layer was made from a lighter, inert material consisting of mixed polystyrene beads and epoxy resin. Barney worked vigorously but never mechanically to build up the core in the centre (fig.108). The final pouring of tapioca took place the next day (fig.109).

The top layer was applied with increasingly precise modelling of the surface. The flat areas were contrasted

LEFT Fig.108 Barney and his assistant building up the core in the centre

OPPOSITE Fig.112 The tapioca bed completed

BELOW Fig.109 The last layer of tapioca being poured

LEFT Fig.110 Barney modelling the raised lip around the holes

ABOVE Fig.111 Barney creating a tapered ridge between the drone and main body which gives the impression that the drone is permanently connected

with a gentle build-up at the centre to form a soft undulating mound that Barney modelled with a spatula. The subtlety of movement within the form was refined by the artist at this stage. The form possesses an organic vitality as it slopes down almost imperceptibly to the holes at either end. The holes are enhanced by a delicately modelled raised lip that the artist precisely sculpted by hand (fig.110). Finally Barney modelled a tapered ridge between each drone and main body which gives an impression of fluency in line between the two as if one grows out of the other (fig.111).

The tapioca was left to set completely for five days before the mould and tins were removed. Once completed, the finished tapioca floor looked identical to the original except that it was in pristine condition (fig.112). The artist was very happy with the outcome, as the perfect surface was the intended finish. The work was left to cure for a month before it was lifted and stored in packing cases. In

the future, it will be stored and displayed in environmentally controlled conditions.

The decision to remake the tapioca could only have been made with the artist, having considered all the options available. There are few examples to compare with such an extreme solution to a difficult problem. The guiding principle in this case was the artist's intent, the age of the work, the availability of the artist and his views to replicate faithfully the original. The technical achievements of Barney are easy to underestimate because of the complexity of his work and subject-matter. Barney is an ingenious sculptor who is very sensitive to the working properties of novel materials. He has more regard for durability than many other twentieth-century artists who use ephemeral materials. Barney's determination to transcend the limitations of his materials and extend the possibilities of tapioca has resulted in a sculpture that we hope will survive for future generations to enjoy.

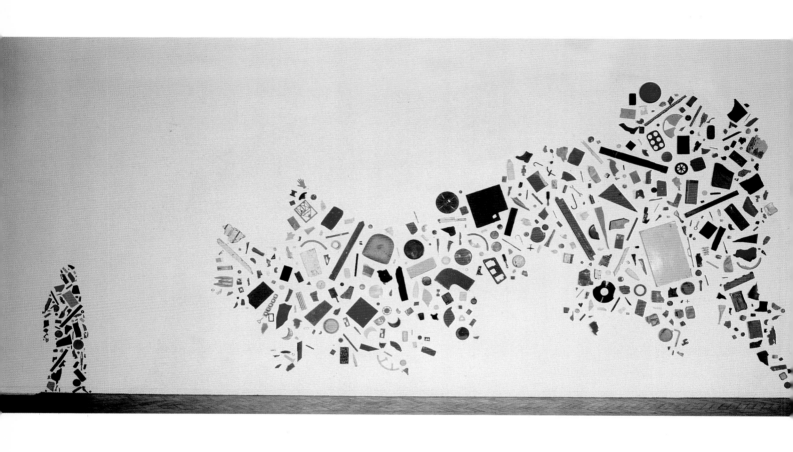

Managing Change – The Conservation of Plastic Sculptures

WORKS BY NAUM GABO (1890–1977) AND TONY CRAGG (born 1949)

Derek Pullen

Plastics are found in sculpture in many forms: paints, resins, structural materials and ready-made objects, to mention just a few. Our approach to the conservation of a wide range of plastic sculptures can, however, be illustrated by examples of the work of two artists, Tony Cragg and Naum Gabo. Their thoughtful attitudes to materials underpin how we conserve their work, with emphasis on preserving both the meaning and the material by good management. To develop conservation standards for plastics we need to identify materials and understand their chemistry, take account of what artists intend when they use novel materials in their sculptures, and acknowledge our own confusion about what we expect of plastics.

Confusion is evident in the popular view that plastic is something that pollutes the environment because it does not change or degrade, when at the same time it is regarded as an impermanent material unsuitable for durable uses, such as sculpture, because it changes and degrades so easily. This ambivalence is exploited in *Britain Seen from the North* (1981) by Cragg (fig.113). The artist collected multicoloured rubbish, including many types of plastic objects, and pinned them to a gallery wall to create his own life-size image surveying an outline of Britain turned on its side. The artist had been working abroad since 1977 and his work is a detached but impassioned portrait of a country then experiencing city riots and record unemployment; a depressing theme reinforced by the distressed condition of the plastics but contradicted by

Fig.113 Tony Cragg, *Britain Seen from the North* (1981), 440 × 800 × 10 cm. T03347

their bright colours. From a distance the effect is decorative but, as Cragg points out, when the spectator realises what the materials are 'a tension is created which has an important function in the work'.[1]

Throughout the century many artists, especially sculptors, have introduced unexpected materials into their work and contributed to the increasing presence of plastics in art collections. In recent years we have become aware that these plastics may not last forever.[2] As with all materials their long-term behaviour and properties are influenced by both internal and external factors. The internal chemical structure and composition of synthetic materials are fixed when they are made, but we have some control over how they are handled and their external environment. All organic materials, whether canvas, wood or plastic, change in response to their environment – to the input of energy from heat, light and mechanical force. They will oxidise, change colour, corrode, rot, soften or become brittle.[3]

Under museum conditions the rate of change may be very slow, taking hundreds of years before an alteration in appearance is noticeable, or it may happen within a few weeks of manufacture. Fortunately Cragg's plastic objects had already survived a form of accelerated natural selection in the open air. The process weeded out those that were degrading or flimsy. The polystyrene, polypropylene, acrylic, polyethylene, and other as yet unidentified consumer plastics used in the sculpture, although aged by exposure, now seem little changed after eighteen years.[4] The work is in good condition as a result of careful handling, regular maintenance by light cleaning avoiding reactive chemicals, stable display and storage environments. However, Cragg has indicated that, if necessary, replacement parts should be selected in the same way as he chose the originals – from the riverbank and roadside.[5]

Only a few changes, such as the acquisition of 'patina', are normally acceptable to artists; change usually means decay. To illustrate both the problems of managing change and the relative stability of the earliest plastics we turn to Naum Gabo, the sculptor most closely associated with plastic as a sculptural medium. He was a pioneer of the constructivist movement and a key figure in the history of modern sculpture.[6] The Tate Gallery and Archive has the largest public collection of his work – over seventy sculptures and models in many different materials. Gabo was the first artist to use plastics extensively in sculpture and he continued to employ several types, combined with metals, glass, stone and wood, throughout his working life.

In 1937 he wrote with passion to validate the use of new materials in the open, transparent forms of Constructive art. 'Materials in sculpture play one of the fundamental roles. The genesis of a sculpture is determined by its material … There is no limit to the variety of materials suitable for sculpture. ... Carved, cast, moulded or constructed, a sculpture does not cease to be a sculpture as long as the aesthetical qualities remain in accord with the substantial properties of the material.'[7]

Later in life he was adamant that his revolutionary sculptural ideas, expressed through the form and qualities of his materials, transcended their actual physical presence. The concepts could survive the loss of their material form or be remade by him in more robust materials on another scale.[8] This is fortunate since a few of the plastics he incorporated in his sculptures have changed considerably and some have actually disintegrated.

More often change is gradual and less final. It can mean that a difficult collaborative decision has to be made as to when a sculpture no longer adequately represents an artist's intent and needs to be withdrawn from display or requires treatment. There is scope for debate and judgement since the artwork is more than just its constituent materials and the viewer unconsciously takes age and condition into account when looking at an object. Many incomplete ancient and medieval sculptures were pigmented but this does not mean that they must be restored and recoloured to be appreciated. Similarly, a small sculpture in Celluloid (cellulose nitrate)[9] by Gabo, entitled *Model for Column* (1920–1) (fig.114), has transparent parts that, like some picture varnishes, have darkened with time but it remains a vivid illustration of his original concept. Later versions of the same sculpture in acrylic sheet, glass and stainless steel remind us how the model might once have been envisioned.[10]

The darkening of the Celluloid in *Model for Column* is probably due to light exposure. All types of light, but especially the ultra-violet component of both daylight and artificial light, can affect plastics causing cumulative and irreversible changes such as yellowing of transparent

Fig.114 Naum Gabo,
Model for Column (1920–1),
14.3 × 9.5 × 9.5 cm. T02167

materials. We can monitor change through photographic documentation and colour measurements, and we try to reduce the rate at which the Celluloid component breaks down, i.e. reverts to cellulose, by controlling its exposure to harmful external factors such as light and heat. Most chemical reactions proceed faster with heat so plastic-based image and sound archives often have very cool storage areas. If plastic sculptures are moved between cold storage and normal gallery temperatures, contraction and expansion stresses can initiate damage. Thus the most practical option is to keep sculptures at a steady temperature, as cool as is comfortable for gallery visitors.

Fig.115 Naum Gabo, *Linear Construction No.1* (1942–3), 34.9 × 34.9 × 4.9. T00191. The nylon strings are both yellowed and fractured

Fig.116 Naum Gabo, *Linear Construction No.2* (1970–1), 114.9 × 83.5 × 83.5. T01105

From the late 1930s Gabo began to use nylon monofilament and Perspex or Plexiglas, trade names for polymethyl methacrylate, to create delicate stringed constructions in which the materials are more stable but any changes are more critical. If an isolated strand of nylon starts to yellow it may not be noticeable but when the strands are massed in hundreds of sharp parallel lines any change in colour or tension is accentuated, as can be seen in *Linear Construction No.1* (1942–3) (fig.115), for example. Such changes can rarely be stopped or reversed but fortunately Gabo was quite explicit that his works should be carefully restrung when their appearance was no longer pristine. However, reconstructing an artwork is never undertaken lightly. The replacement of original material is only considered as the very last resort and reference samples of the original and replacement material are archived.

Linear Construction No.2 (1970–1) (fig.116) is an example of a work that changed soon after it was made. The work was presented to the Tate in 1969 in memory of Gabo's friend Sir Herbert Read, writer, critic and champion of modernist art. The artist said in 1969, 'I decided to make this work … because I know that Herbert was very fond of that image and I myself made this piece so that it differs from all other versions of it.'[11] Shortly after the work was made and given to the Tate, the nylon threads became slack. Gabo knew that his nylon-stringed works responded to changes in their environment and he advised that the sculpture needed to be stored at a steady temperature. Unfortunately the work was badly damaged while being hung in 1970 and Gabo had to remake it in 1970–1. It is displayed and stored in environmentally controlled areas where temperature and, more importantly, relative humidity are kept steady. This has kept it in good condition.

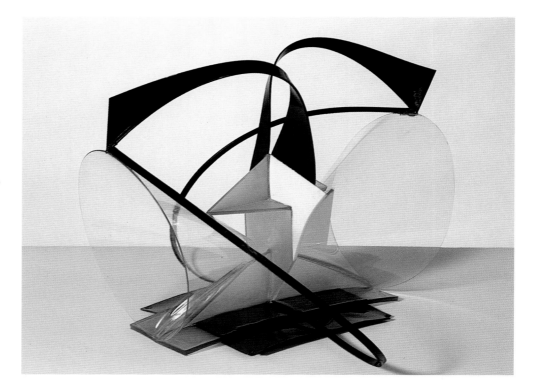

Fig.117 Naum Gabo, *Construction in Space: Two Cones* (1927, reconstructed 1968), 25.1 × 31.1 × 41.9 cm. T02143. Photograph taken in 1980

Although we restore and treat such sculptures when their condition demands it, our primary aim is to manage their care to avoid damage and slow the rate of deterioration. Certain plastics are more at risk than others. Often these have been stabilised or plasticised during manufacture with additives that work well until they are exhausted and then the plastic decays rapidly. A dramatic example occurred several years ago with an important sculpture by Gabo, *Construction in Space: Two Cones* (1927, reconstructed by Gabo 1968) (fig.117). The sculpture appeared stable under a clear acrylic cover that protected it both in storage and on display. When the cover was removed there was a strong vinegar smell and some time later sweat-like droplets appeared on the transparent brown plastic base. Subsequently the base began to warp and eventually cracks and splits appeared (fig.118).[12]

Construction in Space: Two Cones was isolated, examined and analysed. The degrading plastic was identified as Rhodoid, a form of cellulose acetate. The sweating, visible as oily droplets, was a mixture of plasticisers added at the point of manufacture to increase the flexibility and stability of the material.[13] As the decay process proceeds, the plasticiser, which was originally well integrated within the material, is squeezed out and migrates to the surface. We now recognise these as typical symptoms of cellulose acetate degradation. The vinegar smell (acetic acid) is a by-product of the decay process but its presence may also accelerate the rate of degradation. To store the sculpture in a closed container with no means of removing the acid vapours promotes further decay. As cellulosic plastics age and degrade they become more hygroscopic, absorbing and releasing moisture in balance with the amount of water in the atmosphere – measured as relative humidity. They either swell and become softer in moist air or shrink and become more brittle in dry air. The consequent stresses lead to cracking, crazing and distortion. Hence the requirement for very stable environmental conditions.

We rely on scientific and historical research, together with photographic documentation, to provide the data needed to answer the basic questions: what are we dealing with, what is happening and why? In extreme cases of degradation such information may be all that remains. In the example of Gabo's *Construction in Space: Two Cones* photography was taken a little further. We made an actual size hologram that gave a sense of the form of the sculpture before the degradation process was too far advanced.

Fig.118 Detail of the underside of the base of *Construction in Space: Two Cones* showing cracking

Thus there is sufficient information available to make a copy of the sculpture if that is ever thought appropriate. Although in this case a major sculpture was severely damaged we learned the importance of keeping such works in well-ventilated areas with stable humidity and temperature. This has subsequently benefited many similar sculptures in the Tate's and other collections.

The degradation pattern of *Construction in Space: Two Cones* was typical in that only one part, or one type of plastic, was affected. It appeared to happen spontaneously to material that was by no means our oldest or only example. Most plastics remain stable with only acceptable changes taking place. The few that alter dramatically require us to anticipate problems and to look for more effective ways of reducing the rates of change.

Since organic degradation is not limited to sculptures, other technologies may provide assistance. For example, the food industry is now excluding oxygen, one of the main agents of organic decay, from the packaging of otherwise 'natural' foods to extend their shelf life greatly and enable exotic produce to be exported world-wide. Charcoal cloth is used in gas masks and air conditioning systems as a fume filter but it can also adsorb harmful acidic by-products from ageing plastics which might affect other parts of the sculpture or harm works nearby. If change cannot be completely stopped it may be managed and slowed down so that the maximum benefit is gained for those works that are most at risk.

We are committed to collecting, displaying and preserving twentieth-century art in all its forms. At the core of our conservation policy is the resolve to find appropriate solutions and not be put off by the scale or complexity of the problems. Improved research tools and better ways of controlling environments are being devised almost as quickly as artists create new challenges. We can actively conserve and document existing artworks, inform artists and collectors of the risk of change inherent in some plastics, but at the same time encourage them to take risks with new materials. Modern glass and stainless steel might be more stable materials but it would be a very dull world without the variety of images, forms and colours supported by plastics. Their preservation is a continuous effort to comprehend, stem and circumvent change.

Graham Martin of the V & A Museum analysed the plastic and plasticiser of *Construction in Space: Two Cones* using FTIR.

'The Mortal Image' – The Conservation of Video Installations

WORKS BY BILL VIOLA (born 1951) AND GARY HILL (born 1951)

Pip Laurenson

'As instruments of time, the materials of video, and by extension the moving image, have as a part of their nature this fragility of temporal existence. Images are born, they are created, they exist, and, in the flick of a switch, they die. Paintings in the halls of the museum in the middle of the night are still there, a form of sleep, but in the room of the video projections there is nothing. The images are thoroughly non-existent, gone into some other dimension' (Bill Viola).[1]

Video as a medium is now central to contemporary art practice. 'Video' is a broad term used to refer to a wide array of rapidly changing technologies, including the formats in which an artwork might be made, archived and displayed and the equipment used in its presentation. Over the past few years the Tate has acquired a number of ambitious installation works in which video is the primary element. The challenges facing the conservator when caring for these works are often complex and there is little precedent to help define the focus of our efforts. Two works in the Tate's Collection – *Between Cinema and a Hard Place* (1991) (fig.119) by Gary Hill and the *Nantes Triptych* (1992) (fig.120) by Bill Viola illustrate some of these issues.

Viola describes what you see when you look at a video image as 'the decay trace of a single moving point of light',[2] conveying a sense of the fragility of video. Video signals are commonly stored on magnetic tape, although

Fig.119 Gary Hill, *Between Cinema and a Hard Place* (1991), size variable. T07020

Fig.120 Bill Viola,
Nantes Triptych (1992),
size variable. T06854

this is probably something which will change in future years. Modern magnetic tape is made from three different layers,[3] with the metal particles that carry the video signal embedded into the top layer. This top layer is susceptible to chemical deterioration and it is also vulnerable to wear and tear. When videotape is played, the tape heads of the playback machine make direct contact with this upper layer in order to decode the signals. Abrasion to the surface of the tape results in loss of these magnetic particles which results in loss of information. A phenomenon familiar to anyone with a domestic video player, this loss is visible as white streaks across the picture and is known as 'drop out'. Good storage and management will slow the chemical and physical deterioration of magnetic tapes. However, because of obsolescence this is never enough to ensure the long-term preservation of the video.

When a video artwork is acquired by the Tate Gallery, an archival master copy is made on a professional digital tape format. Both Gary Hill and Bill Viola are unusual because they produce digital master tapes of their work. This makes the archiving of their tapes straightforward as they can provide digital clones of their original masters. Most artists, however, still use an analogue format and their material has to be converted into the digital domain for archiving.[4] The conversion from an analogue to a digital signal risks changes to the visual appearance of the video. Therefore, whenever possible, this transfer is done with the artist and the new tape is viewed alongside the original, with two monitors that have been calibrated to match. Digital technology thus enables future copies to be made without the generational loss of information associated with an analogue technology.[5]

In addition to the vulnerability of the video material itself there is the problem of obsolescence in both video formats and the display equipment. The broadcast industry drives developments in video technology: formats change rapidly and any format chosen will eventually become obsolete. Video is a coded system; this means a particular tape or disc can be played only on a machine designed to decode that format. It is pointless to preserve encoded information if the playback machine is no longer available, as essentially video is designed to be read by machines. Rather than attempting to preserve obsolete equipment, however, an ongoing preservation programme ensures that the videos in the collection are always stored in a current format and are monitored and copied on to new stock and new formats when necessary.

With video installations such as *Nantes Triptych* and *Between Cinema and a Hard Place* the challenge for the conservator is twofold: first, to establish the object for display in conditions which, supported by accurate documentation, allow the work to be consistently shown as the artist intended; secondly, to preserve either specific display equipment or equipment which is close enough to enable the re-creation of the installation. Both aspects are important and depend heavily on each other.

Perhaps the least recognised risk to video installations is the work being badly or incorrectly installed. Bill Viola recently compared the video monitor and tape to a musical instrument, 'It comes alive only when you use it. It must be tuned so the music is played properly, so that the scale is correct.'[6] The potential for someone to alter a work radically during installation is far greater than is possible in hanging a painting or placing a bronze sculpture. Imagine if every time a painting was hung the person hanging the painting had the power to make it more or less pink. Then imagine that there was no documentation and nothing more than memory to tell you whether the colour and the contrast of the painting were correct. This is what gives video artworks their unique vulnerability. As a result the conservator's role in the care of these installations is significantly different from the care of traditional artworks.

Between Cinema and a Hard Place is made up of twenty-three monitors of varying sizes; eleven are black and white, and twelve colour. Although the plan for the layout of these monitors is in groups arranged by size, their positioning is not rigidly defined. The arrangement refers to clusters of rocks which demarcate farmland. The images are accompanied by a spoken text and it is important that the words can be clearly heard by the viewer. The text is an excerpt of 'The Nature of Language' by the German philosopher Martin Heidegger. As Hill says of the piece: '*Between Cinema and a Hard Place* plays with the construct of frames as it relates to photography and cinema. Images from single sources are distributed by computer-controlled

Fig.121 *Between Cinema and a Hard Place*, viewer's left back view of nine modified Panasonic 13-inch colour monitors with attached circuit boards on pedestal

electronic switching to several monitors. There are certain sections where scenes divide into two scenes, three scenes and so on. With each division all the scenes slow down – half speed, third speed, quarter speed etc. It is a kind of telescopic time that makes the viewer aware of the process of seeing – of beholding the world through sight that exists in the folds of time.'[7]

The images and the text relate to frontiers which define and delineate space, ownership, proximity and separation. The work examines the relationship between concepts of emotional closeness and of geographical or physical closeness. To the viewer it appears as if the voice triggers an image being sent to a monitor. However, as the piece develops, this correlation between the spoken words and the sequence of the video images is undermined. The

precise technical details are important to the interpretation of the work and it is therefore essential that we carefully document what the control equipment and computer program actually does. This will allow us to replace the equipment in the future when it has become obsolete.

Hill has taken the cathode ray tubes and circuit boards out of the monitor casings, effectively disembowelling the monitors so that the circuit boards and cathode ray technology have become sculptural elements (fig.121). The obsolescence of these monitors poses the greatest challenge to the conservation of this work. The cathode ray tube was first developed in 1897 by German scientist Ferdinand Braun. However, it was not used in the first television sets until the late 1940s. This technology is now 100 years old, and is unlikely to last another 100 years.

Fig.122 Detail of a cathode ray tube

The demise of the old cathode ray tube monitors is already evident since the first flat liquid crystal display panel television was launched in 1997. Although 100 years is a long time in terms of technological developments, it is a short lifespan for an artwork. In order to be able to show this work in the future we will need to replace or repair faulty units and we will need to decide what is acceptable to change. It may not matter that a replacement cathode ray tube is of the same make but it is important that it is not replaced by an entirely different technology. Along with holding a set of spare monitors which can be used for parts in the future, we must also try to predict and document the information which will be of greatest value to future generations of conservators.

Even while operational, the effects of the deterioration of a cathode ray tube can be subtle but devastating to the appearance of the artwork. For example, a typical cathode ray tube has a life of 10,000 to 15,000 hours before it reaches half its initial brightness. The dimming of the picture is due to a loss of emission in the cathode. This means that if the monitors were on display continuously they would need to be replaced at least every three years. In a colour monitor the failure of a tube affects the colour balance, for example a weak red gun would cause the picture to take on a blue hue.[8] This type of imbalance would have a dramatic and detrimental effect on the appearance of the artwork.

A cathode ray tube is made from glass (fig.122). It contains a vacuum in a large tube that can be subject to an atmospheric pressure of several tons. If the tube is damaged, implosion is possible, which would cause glass to scatter. One of the themes explored by this work is the notion of demarcation of physical space and emotional space. By removing the cathode ray tubes from their protective surrounds the manufacturers' safety features are disarmed, transforming these monitors into dangerous objects which have to be barriered off and carefully guarded when on display. It is not clear whether Gary Hill was aware that his treatment of the monitors would bring about this creation of a separate viewing space which serves to reinforce the themes of the work.

In Viola's *Nantes Triptych* the specific display technology is also integral to the artwork. This installation consists of

three large screens arranged side by side. Together in the full version, they are over 8.5 m wide and just over 3 m high. The screens read as a fourth wall, reinforcing a pictorial quality in the 'framed' triptych of images. The back- projected side images show the birth of a child and the death of the artist's mother. The central panel is front-projected through a gauze material into a constructed white space, resulting in a particularly delicate image depicting a man floating in water. Shot in a swimming pool the image relates to the journey between life and death represented by the side panels. Bill Viola says that this central sequence depicts a form of self-portrait 'floating in another world with the experience of life and death'.[9] Its unconscious, dream-like quality reflects the way we do not rationally experience either of these momentous events – birth and death.

Related both to the birth of his son and the death of his mother this triptych of moving images is both deeply personal and universal, mirroring the character of medieval religious triptychs.[10] It is important to recognise the link between the themes in this work and the use of video to represent them. In an interview given in 1992 Bill Viola expressed this relationship in the following way: 'Most important, it is the awareness of our own mortality which defines the nature of human beings … As instruments of time, the materials of video, and by extension the moving image, have as a part of their nature this fragility of temporal existence.'[11]

The combination of the quality of the images, the extraordinary sound and the nature of the space creates the powerful mood of this work. Recognising that cathode ray tube projectors are likely to become obsolete in the future, the artist has said that the projectors used to create the two side images could possibly be replaced by another type of technology, for example large liquid crystal display flat panels. However, the artist feels it is essential that the central image is created using projected light; it seems that Bill Viola might enjoy the idea of conservators of the future learning how to blow glass in order to repair an obsolete cathode ray tube projector.

It is rare for contemporary artists to appreciate their work in a historical context, especially when they work in a technologically driven medium such as video. Bill Viola is an exception. He expresses the idea that looking at early video will one day be as distinctive as looking at a Giotto through contemporary eyes: 'no doubt the first examples of time-based visual art in the twentieth century will be regarded by future observers as being clumsy and childlike, much in the way the modern eye tends to see the medieval painter's first attempts at three dimensional representation as somewhat naïve.'[12]

The video works in the Tate Gallery's collection are important in art historical terms and it is paramount that the unique qualities of the original are preserved. The quality of a particular video artwork will be affected by a number of factors including the technology available when it was made, the skill of those involved, budget restrictions, and the intention of the artist. It is important that these aspects are preserved and that the material is not indiscriminately 'improved' or altered. Keeping things as they are is harder than one might think, especially in relation to display equipment such as projectors. The equipment for the *Nantes Triptych* is tightly specified and it would alter the character of the images if the original cathode ray tube projectors were replaced with more sophisticated models. Viola is very clear that he does not want these types of 'improvement' to be made, and that the work should stand as it is, as a piece made at a particular time, reflecting the technology available at that time.

Because the fragility of video art is of a different nature to other media, so too is the focus of its conservation. The Gallery aims to preserve all the works in the Collection so that they can be displayed and loaned to others in the future. Part of preserving this possibility is about decoding electronic signals to create images and sound in keeping with the artist's intent and the original meaning of the work. In the installations of Bill Viola and Gary Hill, the display equipment and the details of the installation are integral to the artwork, and therefore the key to their conservation. It is important to define what is essential to a specific work and what changes are acceptable. Hill has likened the installation of one of his sculptures to a performance of a piece of music. There are good and bad performances. As custodians of these works it is important for the conservator to know and record what constitutes a good performance.[13]

Methods of Examination and Analysis for Sculpture

Joyce Townsend

Before any of the conservation treatments described in this book were proposed, the conservators had to establish what they were dealing with. Fundamental questions had to be answered, such as what was the sculpture made of, how was it made and how has it aged or changed. Examination and analysis are the complementary techniques used to provide the answers. The choice of a particular analytical technique depends on what we are looking for. It is also informed by a knowledge of the sensitivity of a particular technique to the small quantity of sample that is usually available.

Of course not all methods are applied to every sculpture. An examination always starts with simple but thorough observation and employs increasingly sophisticated tools when further questions, thrown up by the initial viewing, warrant deeper investigation. Similarly the choice of a particular analytical technique depends on what we are looking for. The ideal examination is non-destructive, but sometimes very useful information can be gained through taking tiny samples. Therefore any analytical tool used has to be sensitive at the microgram level. It should also be capable of identifying several components in a mixture of materials which may individually have altered with age.

Detailed observations in the conservation studio give the examiner vital clues. Observations can be recorded photographically or by written descriptions. For a three-dimensional object, several viewpoints are necessary if the whole object is to be depicted in photographs, and detailed images from many viewpoints may also be needed. **Close-up photography** and **photography through a microscope** are inherently challenging for sculptures, because appropriate lighting may be difficult for dark surfaces, shiny metallic ones or deeply undercut structures.

Lighting small areas of a sculpture with raking light from a point source provides information about the texture of the surface, and any deformations which may have developed in it.

We use a **stereo microscope**, with typical magnification of times 7 to 40 to assist visual examination. A light is concentrated on the area to be inspected, usually from a tungsten-halogen bulb through fibre-optic guides, which also filter out unwanted radiation and prevent excessive heating of the illuminated surface. The fibre-optic guides are flexible, and allow light to be directed into hollows and undercuts. At lower magnifications, features evident to the naked eye become easier to see, for instance: brushstrokes, toolmarks on the original piece or the mould used to create it, joins between cast pieces of metal, cracks, small damages, lifting and flaking paint, or damage in a coating intended to offer protection against the weather. At higher magnifications, different pigments mixed to form a paint can be distinguished.

Technical photography is a useful non-destructive tool for recording what has already been observed or for revealing invisible aspects. Many organic materials including paint media and coatings on plaster casts, such as shellac, exhibit **ultraviolet fluorescence**, that is, they emit visible light when illuminated with ultraviolet radiation. Fluorescence can also reveal the evenness of application of a coating or retouching on top of a coating. Such retouching may be the work of a previous restorer and can be distinguished from the artist's own work.

Examination with an **infra-red vidicon** exploits differences in the transmission through a surface exposed to infra-red (IR) radiation. Unlike fluorescence the reflected radiation cannot be seen directly by the eye. It requires either a photographic film or a detector sensitive in the infra-red region, as employed in the vidicon system. The transmission of IR radiation through a paint or corrosion film to the substrate beneath depends on its composition and the thickness of the film.

As in medical applications, x-radiography is used to reveal dense material that is opaque to x-rays. In the medical field x-rays are absorbed by bones and transmitted by most other body tissues; in the conservation field it is metals that absorb x-rays strongly. X-rays can reveal details about construction, including the location and size of armatures, as well as giving valuable information about the construction of the work. The x-rays are produced by an x-ray tube, and are detected by a film placed on the other side of the object. Thick castings require higher-energy x-rays than thin wires or dowels, and equipment developed for **industrial x-radiography**, for the inspection of welds, for example, may have to be used for some objects. Exposure is by trial and error, altering the voltage on the x-ray tube to compensate for differing thicknesses and materials: 300 kV or even 500 kV may be used, in contrast to the lower voltages of 10–50 kV used to examine paintings. It is possible to take two x-ray images from slightly different viewpoints, then photograph the films and view them through a stereo viewer to obtain a three-dimensional image of the dowel or armature. This allows the conservator to visualise its position within the sculpture. **Metal detectors**, in contrast, can only indicate that a metallic structure lies beneath the surface; they cannot localise it or indicate its shape.

To obtain further information about a surface, small samples can be taken for analysis. The maximum size of a sample is limited by the need for its removal to be invisible under all normal viewing conditions, and its minimum size depends on the use to which it is to be put. For identifying the principal component, most analytical techniques are sufficiently sensitive to succeed on the smallest sample that can be removed and manipulated. For instance, analysis of the surface pigments, or confirmation whether the surface layer includes dirt alone or pigments as well, may only require a few scrapings. But for detecting some minor components of a complex mixture or the medium of a leanly applied coating or paint film, it may not always be possible to take a sufficiently large sample. **Cross-sections** also provide sampling problems because a sample must be taken through more than one layer and remain coherent. Cross-sections from metal sculptures rarely include the metal itself, because it is so hard that the removal of a tiny sample is not practicable, but all the corrosion layers and the original patinated or painted surface are included and serve to clarify the structure. The sample is placed on a block of transparent synthetic resin in a mould, and further resin is added to encapsulate it.

The block is then ground down until the sample is exposed edge-on. It is then polished and viewed in reflected light under an **optical microscope**.

Paint layers, at least those applied in traditional materials, have a noticeable **ultraviolet fluorescence** when the cross-section is viewed in ultraviolet light, and can thus be distinguished from patination and corrosion layers. The interface between paint layers indicates whether they were applied wet-in-wet or after a period of drying, and the thickness of each layer indicates its purpose and application. Paint intended to protect against corrosion is applied thickly, for example, whereas paint used to imitate the surface appearance of bronze may be painted wet-in-wet to give a variegated and more convincing surface. **Staining of the cross-section** with stains specific for proteins or drying oil further helps to identify the different layers.

Inorganic pigment analysis can be carried out with **optical microscopy**. A sample of paint is dispersed on a microscope slide, in a liquid or resin of known refractive index, and viewed in transmitted light. Examining the optical properties of the inorganic pigments present allows a skilled and experienced microscopist to identify most of the commonly used pigments, even in quite complex mixtures. Virtually all historic pigments can be identified, because they were ground by hand and tend to have large particles. From the mid-nineteenth century onwards, many pigments were machine-ground, and most today are too finely ground for the optical microscope to resolve their distinguishing features. Other techniques have to be used to back up judgement in these cases. Optical microscopy can be used to **identify wood fibres**, and to **identify textile fibres**, at least those of natural origin such as cotton. Samples of fibres, pigments and applied coatings can be examined in liquids of different refractive indices, in order to eliminate a few possibilities for their identification, and then to make a more rational choice about the best way to analyse a sample of very limited size.

We can identify pigments, including metallic ones, by analysing the elements that are present. Elemental analysis may also help to distinguish between corrosion products and pigments. Most **scanning electron microscopes** (**SEMs**) are equipped to carry out such analysis, which is known as **EDX, energy-dispersive x-ray analysis**, or **electron probe micro-analysis** (**EPMA**). In practice the technique is often used to distinguish between two or three possibilities when the pigment or corrosion particles look similar, or are very finely ground. It reveals unexpected elements, should they be present, and can also be used to infer the presence and type of extenders in the paint. This in turn might suggest whether the paint is of artists' quality, with only small amounts of extenders present, or whether it was purchased as cheaper house paint, which has a greater proportion of extenders. Electron microscopes can provide very high magnifications, which are useful when a study of paint defects or deterioration is being carried out, but in practice a high magnification may not be required for elemental analysis. It is possible to calculate quantitatively how much of each element is present. This is a useful tool for metals, and can be used to identify which alloy was used for a sculpture, or whether a surface was plated, since plated surfaces consist of a single metal with high purity. Corrosion products and pigment mixtures in paint are too complicated for such calculations to be carried out accurately.

To identify a crystalline corrosion compound more exactly, **x-ray diffraction** (**XRD**) is used. The structure and spacing of atoms can be characterised by the way x-rays interact with them. The resulting diffraction pattern can be compared to patterns for known minerals and chemically induced corrosion layers.

The **identification of paint media, varnishes and coatings** can still provide a considerable challenge. Oils traditionally used by artists, such as linseed, walnut and poppyseed, are chemically somewhat similar, and consist of different proportions of a number of common components. Similar oils have been used to protect wood exposed outdoors. Some of these components alter chemically on ageing, and some can interact with other materials found in traditional paints and protective coatings, such as natural resins and waxes. As a consequence, the analysis of historic paint media and colourless coatings may involve the recognition of compounds that were not even present at first. Two approaches have been used for this problem: broad characterisation of chemical class, and initial separation of all the components so that the more

abundant or more characteristic ones can be identified separately.

The technique known as **FTIR (Fourier transform infra-red spectroscopy)** is used for broad characterisation of chemical class. Its working principle is that particular chemical bonds absorb infra-red radiation of characteristic energy; the amount of infra-red energy transmitted at each wavelength then indicates whether and how strongly a bond has absorbed energy. This information can be used to work out the structure of a compound, or, more usually, to compare its infra-red spectrum with that from known materials. The method can, for example, indicate that a wax or a resin is present, but not which ones. Complex formulations can be very difficult to interpret with this technique, though simpler mixtures can be identified with confidence. FTIR has been used successfully to identify the polymers and plasticisers in plastics, and also for recognising and measuring the extent of chemical changes as plastics degrade and alter.

Thermomicroscopy can indicate whether a wax is present in a coating or a paint medium. It involves heating a sample at a controlled rate, while observing it through a microscope to see when it softens, melts, or starts to darken and char. Waxes, for example, melt over a narrow temperature range, and if the sample remains unchanged when heated beyond the melting point of common waxes, this gives the conservator useful information on their absence. It also indicates whether the coating can withstand a localised treatment which involves heating.

The best characterisation of complex samples of paints or coatings involves separating all the components, by a technique known as **chromatography**. Typically, the organic material is extracted with a solvent, then heated and/or treated chemically to improve the detectability of each component, a method which relies on a detailed knowledge of the chemistry of all the materials which might be present in the sample. Then the solution is run through a specially prepared column which slows each component by a different amount, so that they can be detected as they come out one by one. If gas is used as the carrier, the technique is called **gas chromatography (GC)**. The best way to make use of valuable and tiny samples is to detect all the components as efficiently as possible. Today a **mass spectrometer (MS)** is used. Another way of preparing samples of paint and coatings for separation in a gas chromatograph is to heat them strongly until they break down to smaller fragments. This technique, **pyrolysis**, is very useful for non-traditional paint and polymers, which cannot be dissolved in solvents as readily as traditional paints can. The combined analytical method is then known as **Py-GC-MS.** A less common method is to heat and break down a sample with energy supplied from a laser, and then to identify the resulting fragments with a mass spectrometer: this is known as **laser ionisation mass spectrometry (LIMA).**

In every case, analysis provides objective information. However, to be useful it has to be interpreted in the context of the sculpture and our understanding of fabrication and decay processes. Furthermore this interpretation must be incorporated into a wider model of what constitutes the sculpture. Conservation scientist, conservator and art historian each play a part in establishing this model and each needs to try to understand the contributions of their respective colleagues. When this happens the multidisciplinary approach provides exciting insights into our understanding of artists and their work.

Notes

Introduction

1. For a general overview of the conservation of paintings, see D. Bomford, *Conservation of Paintings*, London 1997; for technical analysis of paintings, see S. Hackney, R. Jones and J. Townsend (eds.), *Paint and Purpose*, London 1998.

2. Vasari as quoted by D. Lowenthal, *The Past is a Foreign Country*, Cambridge 1985, p.171.

3. I. Jenkens, '"Gods without Alters": The Belvedere in Paris', *Il Cortile Delle Statue*, Mainz am Rhein 1998, pp.459–70.

4. B. Hepworth, British Council Lecture, 'The Sculptor Speaks', 23 Mar. 1970, TGA.

5. Tate Gallery Records, July 1984.

Chapter 1: Edgar Degas

1. This date for Marie's birth was recently established by Anne Pingeot and Theodore Reff and revealed at the Symposium 'Positioning Degas' Little Dancer' held at the Joslyn Art Museum, Omaha, Nebraska, Apr. 1998. It was previously thought to be Feb. 1878. The new date indicates a more intense period of work on the piece for Degas.

2. J.-K. Huysmans, 'L'Exposition des Indépendants en 1881', *L'Art Moderne*, Paris 1883, p.226.

3. 'Plasticene' or 'plastilene' is a non-drying modelling clay. In Degas's day it was commercially available and contained oil and 'flowers of sulphur' (sulphur crystals). This latter addition has led to the corrosion of internal metal armatures in some of the sculptures. A cache of 'La Plasteine' from the same period was recently found in the Musée Gustav Moreau, supplied by the Parisian firm of Sennelier.

4. Joseph Durand-Ruel, letter to Royal Cortissoz, 7 June 1919, Beinecke Rare Book and Manuscript Collection, Yale University.

5. S. Campbell, 'A Catalogue of Degas' Bronzes', *Apollo*, vol.142, no.402, Aug. 1995, pp.6–48.

6. D. Barbour, 'Degas's Wax Sculptures from the Inside Out', *Burlington Magazine*, vol.134, no.1077, Dec. 1992, pp.798–805; P. Failing, 'The Degas Bronzes Degas Never Knew', *Art News*, Apr. 1979, pp.38–41, 'Cast in Bronze – the Degas Dilemma', *Art News*, Jan. 1988, pp.136–41, and 'Authorship and Physical Evidence (the Creative Process)', *Apollo*, vol.142, no.402, Aug. 1995, pp.55–9.

7. Ibid.

8. Failing 1979, pp.38–41 (citing the findings of Arthur Beale, then head conservator at the Fogg Museum, presented by him at a Fogg Museum symposium in 1977).

9. F.N. Bohrerin, *Joslyn Art Museum, European Paintings and Sculpture*, Omaha, Nebraska 1987, pp.101–2 and A. Beale, 'Little Dancer Aged Fourteen: The Search for the Lost Modèle' in *Degas and the Little Dancer*, exh. cat., Joslyn Art Museum, Omaha, Nebraska 1998, pp.97–108.

10. There is some debate as to how coloured waxes would have been applied to the surface of a bronze. Some foundrymen I spoke to felt that beeswax would not take to the surface. Harder waxes can take to smooth bronze surfaces especially if applied hot (bootpolish is one example and the darker wax used on the *Little Dancer Aged Fourteen* may be nothing more than this). One patinator suggested that pigments could have been applied to the heated surface in a medium, such as shellac or even water, and then a hot wax applied into which the pigments subsequently migrated. However, all microscope examination and samples taken in the course of this examination indicate that the wax and pigments are completely homogenous. In addition, the initial patination could have provided a 'key' for the application of the coloured wax.

11. The contemporary critic Charles Ephrussi complained of unblended, different coloured wax and 'dirty areas which spoil the general appearance', suggesting that these dark patches may indeed be original. Quoted in R. Kendall, *Degas and the Little Dancer*, exh. cat., Joslyn Art Museum, Omaha, Nebraska 1998, p.41.

12. J. Heuman and J. Townsend, 'Searching for Pigments on Fabric: Degas' *Little Dancer Aged Fourteen*', *Conservation News*, no.42, July 1990, pp.11–12.

13. The software for this project was supplied by Dynamic Data Links who also helped conservators to design a database to organise the captured images.

Chapter 2: Frederic, Lord Leighton

1. S. Beattie, *The New Sculpture*, New Haven, Conn. 1983, p.3. See also 'Writing about the New Sculpture in 1894', *Art Journal*, 1894, p.140.

2. E. Staley, *Lord Leighton of Stretton PRA*, New York 1906, p.131.

3. 'Artists as Craftsmen. No.1. Sir Frederic Leighton Bart., P.R.A., as a Modeller in Clay', *The Studio*, Apr. 1893, pp.1–7.

4. S. Whatmore, 'From Art to Industry: Developments in English Bronze Casting during the Nineteenth Century' in J. Heuman (ed.), *From Marble to Chocolate: The Conservation of Modern Sculpture*, London 1995, p.52.

5. L. Lang, 'The Sculpture of the Year', *Art Journal*, 1986, p.332.

6. Conservation work in 1991 at the Royal Academy of Arts on the plaster of *An Athlete Wrestling with a Python* also revealed that the underlying surface seemed to incorporate a layer of gilding on the python. See *Frederick Leighton*, exh. cat., Royal Academy of Arts, London 1996, p.182.

7. D. Lowenthal, *The Past is a Foreign Country*, Cambridge 1985, p.155.

8. J. Heuman, 'Perspectives on the Repatination of Outdoor Bronze Sculptures' in P. Lindley (ed.), *Sculpture Conservation: Preservation or Interference*, Aldershot 1997, pp.121–7.

9. For full detailed discussion of treatment see J. Heuman, 'Removing Corrosion on a Painted Outdoor Bronze Sculpture with Mild Chelating Agents', *The Conservator*, UKIC, no.15, 1992, pp.12–18.

Chapter 3: Edward Onslow Ford

1. H. Read, *Victorian Sculpture*, New Haven, Conn. 1982, p.231: 'Ford's *Folly*, 1886, is sometimes claimed as the first work cast by the revived lost-wax method actually in this country.'

2. *Catalogue of the Pictures and Sculptures in The National Gallery of British Art*, London 1898, p.183.

3. *Royal Academy Pictures*, London 1893, p.126.

4. Research carried out by Terry Riggs, Curator at the Tate Gallery.

5. The decorative motifs on the base of *Applause* were created by incising a green marble base and gilding the hollows; silver was also used for some of the details, for example the snake's head on the head-dress of the figure.

6. *Royal Academy Pictures*, London 1899, Wolfram O. Ford painting *My Father*, p.117. Wolfram Onslow Ford died in obscurity as a patient at Horton Hospital. A letter from the hospital to the Royal Academy asking if it could possibly be true that this man was the son of a famous artist is filed in TGA.

7. The 'enamel' was found to contain a large proportion of calcium carbonate and triterpenoid resin. Cross-sectional analysis and pigment analysis were carried out both before and after the wax layer was removed. The blue 'enamel' layer gave a strong UV fluorescence suggestive of oxidised natural resin. For full details of analysis and treatment, see P. Laurenson, 'Case Study of a Nineteenth Century Bronze Sculpture with a Decorative Resin Inlay' in J. Heuman (ed.), *From Marble to Chocolate: The Conservation of Modern Sculpture*, London 1995, pp.15–22.

8. A nineteenth-century commemorative brass plaque known as the Waller Brass at the Victoria and Albert Museum has a medieval-style decorative inlay in red, white and blue which is thought to be a resin-based material (personal communication with Diana Heath, Head of the Metals Conservation Section, V & A Museum, London). More in-depth analysis has been carried out on the remaining inlays from a monumental brass plaque of Canon Oskens made in Germany in 1535 and now in the V & A Museum. The inlay material was composed of a wax/rosin mix pigmented with vermilion, malachite and azurite in different areas. See M. Norris, *Monumental Brasses: The Craft*, London 1978, report of analysis carried out by the National Gallery, London, quoted on pp.112–13; J. Coales, *The Earliest English Brasses: Patronage, Style, Workshops 1270–1350*, London 1987, pp.12–13.

9. A. Blühm, *The Colour of Sculpture, 1840–1910*, exh. cat., Van Gogh Museum, Amsterdam 1996.

Chapter 4: Constantin Brancusi

1. J. Mundy (ed.), *Brancusi to Beuys – Works from the Ted Power Collection*, exh. cat., Tate Gallery, London 1996, p.24.

2. P. Hulten, N. Dumitresco and A. Istrati, *Brancusi*, London 1988, p.162, mention the following founders: Grand, Florentin Godard, P. Converset and later the Fonderie Cooperative des Artistes (p.178). At least fifteen bronzes were cast here in 1926 so it is likely this is where the *Fish* was cast.

3. A.T. Spear, *Brancusi's Birds*, New York 1969, p.25 n.24.

4. R. Varia, *Brancusi*, London 1986, p.270.

5. Spear 1969, p.24 n.18.

6. M. Rowell, 'Timelessness in a Modern Mode' in F.T. Bach, M. Rowell and A. Temkin, *Constantin Brancusi 1876–1957*, exh. cat., Philadelphia Museum of Art, Philadephia 1995, p.48.

7. Hulten, Dumitresco and Istrati 1988, p.116.

8. Ibid. pp.183, 204. Spear 1969 also quotes Brancusi's assistant Noguchi as saying that the artist told him he had great difficulty obtaining a polished disc for one of his *Fish*. He showed him one that he had had made in Germany which was 'Of course much better

than what could be had in France but still so far from perfect that he had to redo the whole thing himself'.

9. A photograph of the interior of Brancusi's studio dating from 1946 (reproduced in Hulten, Dumitresco and Istrati 1988, p.249) shows the *Fish* on this base.

10. Bach, Rowell and Temkin 1995, p.377.

11. Ibid. p.236. This version of *Newborn* now rests above an ovoid-shaped wooden base, the central cavity of which is very similar to this one.

12. Ibid. p.27.

13. C. Quirot, 'L'Atelier de Brancusi au Musée National d'Art Moderne, Paris', *La Revue du Louvre et des Musée de France*, vol.46, Apr. 1996, pp.77–86.

14. Spear 1969, quoting early articles by M. Morsell and D. Dudley, p.22.

15. Quirot 1996, p.81, quoting Noguchi, 'une enorme cognee plutot que d'une doloire elle tombait lourdement son tranchant mettant en evidence la texture comme si elle etait polie'; this corresponds closely with the texture of the surface of this base.

16. Isamu Noguchi, Natalia Dumitresco and Alexandre Istrati.

17. Quirot 1996, p.81.

Chapter 5: John Skeaping

1. J. Skeaping, *Drawn from Life: An Autobiography*, London 1977, p.101.

2. Ibid.

3. F.G. Prince-White, 'Horse Carved from 2 1/2 Ton Mahogany', *Daily Mail*, 12 Jan. 1934, TGA.

4. *Daily Sketch*, 24 Jan. 1934, TGA.

5. *Daily Mail*, 12 Jan. 1934, TGA.

6. 'Art in London: The Artist as Showman: Skeaping's Methods', *Scotsman*, 20 Jan. 1934, TGA.

7. Skeaping 1977, p.101.

8. Ibid.

9. *Daily Express*, 16 Oct. 1933, TGA. Skeaping describes how the blood should be applied no more than fifteen seconds after the death of the animal.

10. N. Skeaping in *John Skeaping 1901–1980: A Retrospective*, exh. cat., Ackermann & Son, London 1991, p.7.

Chapter 6: Henry Moore

1. R. Melville, transcript of a talk by Henry Moore, 'Sculpture in the Open Air', British Council 1955, TGA.

2. Ibid.

3. Ibid.

4. Ibid.

5. J. Soby, Director of the Museum of Modern Art, letter to Mr J. Rothenstein, Director of the Tate Gallery, 9 June 1944, unpublished, TGA.

6. J. Rothenstein, Director of the Tate Gallery, letter to Henry Moore, 23 June 1944, TGA.

7. B. Steingraber, *Henry Moore Maquettes*, London 1978, p. 85.

8. G. Levine, *With Henry Moore*, London 1978, p.57.

9. Personal communication with Bernard Meadow, 7 Dec. 1998.

10. Letter from A. Simkins, McNay Art Institute, 28 Jan. 1976, to the Tate Keeper of Twentieth Century Art, Tate Gallery Records.

11. Levine 1978, p.146.

12. Melville 1955.

13. Levine 1978, p.131.

14. Personal communication with Bernard Meadow, 7 Dec. 1998.

15. Ibid.

16. Ibid.

17. Ibid.

18. 'The Sculpture Speaks', *The Listener*, 18 Aug. 1937, as quoted in *Tate Gallery Modern British Paintings, Drawings and Sculpture*, London 1964, p.446.

19. Melville 1955.

20. Steingraber 1978, p.82.

21. Melville 1955.

Chapter 7: Allen Jones

1. Personal communication, 1998.

2. V. Arwas, 'Allen Jones' in *Allen Jones*, London 1993, p.39.

3. Personal communication, 1999.

4. Arwas 1993, p.39.

5. Conservators Sian Pybus and Don Sale carried out the initial documentation,

research and treatment of the sculpture (1987–90).

Chapter 8: Antony Gormley

1. Personal communication, Dec. 1998.

2. P. Moorhouse, entry in *Tate Gallery Illustrated Catalogue of Acquisitions 1982–84*, London 1986, pp.189–90.

3. Personal communication, Dec. 1998.

4. J. Lomax, 'Antony Gormley', bulletin sheet, Whitechapel Art Gallery, London 1984.

5. Moorhouse 1986, pp.189–90.

6. Personal communication, Dec. 1998. See also L. Biggs, I. Blazwick and S. Nairne, *Objects and Sculpture*, exh. cat., Institute of Contemporary Arts, London, and Arnolfini Gallery Ltd, Bristol 1981, p.18.

7. Ibid.

8. L. Biggs, *Antony Gormley*, exh. cat., Tate Gallery Liverpool 1993, p.40.

9. S. Ala, *Antony Gormley*, London 1984, p.xii.

10. Biggs *et al.* 1981, p.18.

11. Personal communication, Dec. 1998.

12. Ibid.

13. J. Hutchinson, E.H. Gombrich and L. Njatin, *Antony Gormley*, London 1995, p.118.

Chapter 9: Matthew Barney

1. N. Wakefield , 'Matthew Barney's Fornication with the Fabric of Space', *Parkett*, no.39, 1994, p.123.

2. S. Rainbird, 'Matthew Barney', exh. leaflet, Tate Gallery, London 1995.

3. J. Romney, 'Sheep or Goat', *Guardian*, 13 Mar. 1998.

4. Wakefield 1994, p.120.

5. Personal communication with Sean Rainbird, Curator at the Tate Gallery.

Chapter 10: Naum Gabo and Tony Cragg

1. See *Tate Gallery Illustrated Catalogue of Acquisitions 1980–82*, London 1984, p.74 (entry compiled by Sean Rainbird).

2. See *Saving the Twentieth Century: The Conservation of Modern Materials*, Canadian Conservation Institute, Ottawa 1993.

3. J.S. Mills and R. White, *The Organic Chemistry of Museum Objects*, London 1987.

4. D. Braun, *Simple Methods for Identification of Plastics*, New York 1982.

5. Tate Gallery catalogue file (Pat Turner interview) and also discussed at International Co-operation on the Conservation of Contemporary Art project, Amsterdam 1996.

6. S.A. Nash and J. Merkert, *Naum Gabo: Sixty Years of Constructivism*, Munich 1985.

7. Naum Gabo, 'Sculpture: Carving and Construction in Space' in N. Gabo, *Constructions, Sculpture, Paintings, Drawings, Engraving*, London 1957, pp.167–8 (reprint of article first published in *Circle: International Survey of Constructive Art*, 1937).

8. Personal communication with the artist's family, 1999.

9. M. Kaufman, *The First Century of Plastics: Celluloid and its Sequel*, London 1963, pp.33–40.

10. C.C. Sanderson and C. Lodder, 'Catalogue Raisonné of the Constructions and Sculptures of Naum Gabo' in Nash and Merkert 1985, pp.206–7. Nine versions of *Column (Catalogue Raisonné* 10.1–10.9) are described of which the Tate Gallery model is *Catalogue Raisonné* 10.1 (fig.114).

11. *Catalogue of The Tate Gallery's Collection of Modern Art*, London 1981, p.266.

12. J. Heuman and D. Pullen, 'Cellulose Acetate Deterioration in the Sculptures of Naum Gabo' in *Modern Organic Materials*, Scottish Society for Conservation & Restoration, Edinburgh 1988, pp.57–66.

13. Analysed as a mixture of tri-phenyl phosphate, di-ethyl phthalate and a sulphonamide.

Chapter 11: Bill Viola and Gary Hill

This title is taken from Bill Viola's seminal essay 'Video Black – The Mortality of the Image'. The idea of a mortal image is also referred to by Bill Viola in 'Putting the Whole Back Together, in conversation with Otto Neumaier and Alexander Puhringer' in

R. Violette, *Reasons for Knocking at an Empty House: Writings 1973–1994*, exh. cat., Anthony d'Offay Gallery, London 1995. On page 278 of this interview Bill Viola says, 'I wrote an article a few years ago entitled "Video Black – The Mortality of the Image" where I tried to show that an image now is mortal, it has been given a birth a death, and therefore has a finite existence.'

1. Violette 1995, p.278.

2. Ibid. p.204.

3. The top layer of a modern magnetic tape is a binder layer made from polyester polyurethane. The second layer is a support layer made from a very stable polyester poly(ethylene terephthalate). The third layer is optional and is a backing layer which is usually made from the same material as the binder layer but embedded with carbon black rather than metal particles. For a detailed discussion of the structure of magnetic tape, see M. Baker, 'Lifetime Predictions for Polyurethane-Based Recording Media Binders: Determination of the Shelf-Life of Videotape Collections' in *Resins Ancient and Modern*, Aberdeen 1995, pp.106–10.

4. For a description of the Tate Gallery's procedure for the conservation of video artworks see P. Laurenson, 'The Conservation and Documentation of Video Installations' in *Modern Art: Who Cares*, Amsterdam 1999.

5. If an analogue copy is made from an analogue tape, information is lost. If a copy is then made from the copy even more information is lost, and so on. This is what is meant by generational loss. With a digital tape, when a digital copy is made, this generational loss does not occur and the copies are called clones. It is important, however, to check the condition of digital tapes annually and plan to transfer the material on to new stock every five or six years.

6. W. Shank, 'To Save a Snowman for Posterity?', *The Art Newspaper*, no. 82, June 1998.

7. 'Gary Hill. Inter – View', excerpts of interviews, rewritten by Gary Hill in *Gary Hill*, exh. cat., Stedelijk Museum, Amsterdam, and Kunsthalle, Vienna 1993.

8. Colour monitors work on an additive colour system using red, green and blue. In the neck of a cathode ray tube for a colour monitor there are three guns which fire a beam of electrons to the screen. The screen is made up of red, green and blue phosphor dots. The green gun controls electrons which strike only the green phosphors and so on. One weak gun would therefore cause an imbalance in the picture colour. For further information see B. Grob, *Basic Television and Video Systems*, 5th edn., London 1984.

9. Quoted by Sean Rainbird from an interview with the artist in 1994, unpublished.

10. Taken from notes by Sean Rainbird, Tate Gallery Records, 1994.

11. Violette 1995, p.278.

12. Violette 1995, p.204.

13. Personal communication with the artist, Feb. 1999.

Glossary

Acrylic: stable modern synthetic *resin* widely used in various formulations as a water (emulsion) or *solvent*-based *binder* for paints and consolidants.

Acrylic sheet: polymethyl methacrylate, a clear or coloured sheet material commercially available as Perspex (UK), Plexiglas (US), and Lucite (US).

Adze: tool with a concave blade set perpendicular to the handle, used for the preliminary roughing out of a wood carving.

Aggregate: any granular material that when mixed with a *binder* forms a strong solid compound, e.g. sand, gravel.

Alkaline: a property of water-based solutions, such as ammonia and caustic soda (sodium hydroxide), that breaks down chemical bonds within organic materials faster than water alone.

Alloy: a combination of two or more metals.

Aluminium: a modern light-weight metal available to artists since the mid-nineteenth century.

Armature: an internal support framework for sculpture, usually of wood or metal.

Azurite (basic copper carbonate): a blue *pigment* derived from the mineral of the same name.

Beeswax: natural wax secreted by bees to make their honeycombs.

Binder: component of a paint, filling or casting solution that helps form a solid cohesive substance when dry.

Block and tackle hoist: a device for lifting heavy weights using rope and pulleys.

Brass: a yellow *alloy* of *copper* and zinc, with lesser amounts of other metals such as lead and tin.

Bronze: an *alloy* of *copper* and tin, sometimes containing a little zinc and lead. *Bronze* remains the preferred metal for casting sculpture. See page 46.

Butt joint: a joint made between materials lying edge to edge in the same plane.

Carborundum stone: a hard, artificial abrasive composed of silicon carbide, used to polish stone and sharpen metal tools.

Cast: a form created by pouring liquid material, such as *plaster* or molten metal, into a *mould*.

Cellulose acetate: a semi-synthetic plastic (cellulose treated with acetic acid) used by artists since the 1920s.

Cellulose nitrate: a semi-synthetic plastic (cellulose treated with nitric acid) used by artists since the 1900s.

Celluloid: trade name for cellulose nitrate

Chelating agent: a class of chemical compound which traps metal ions, making *corrosion products* more soluble and therefore more easily removed.

Chlorine: an aggressive gas that reacts with water and metals to form chloride salts, which promote corrosion, the alteration of metal surfaces and *patina*.

Chrome yellow: an opaque yellow *pigment* made from lead chromate.

Claw tool: a stonecutter's chisel with a toothed edge, often referred to as a tooth chisel.

Cloisonné: a technique for surface decoration of metals by which shallow compartments (cloisons), formed by thin metal strips, are filled with a coloured vitreous or *resin* paste.

Copper: a pinkish-gold metal that is the dominant component of *bronze* and *brass*.

Copper chloride: see *chlorine* and *corrosion products*.

Copper sulphate: see *corrosion products*.

Copper sulphide: see *corrosion products*.

Corrosion products: metallic salts, such as copper sulphide, copper sulphate, copper chloride and lead carbonate, formed by the interaction between a metal and its environment which results in changes in the properties of the metal.

Crazing: visible fine cracks or fissures in a surface.

Cure: the process by which a material such as adhesive or *resin* becomes hard. See also *epoxy resin*.

De-ionised water: water with soluble impurities removed.

Derrick: equipment used for moving or hoisting heavy weights.

Direct carving: a method of carving practised by sculptors, including Constantin Brancusi and Henry Moore, by which the sculptor carves directly into the material as opposed to transposing precisely from clay or other material. Direct carving does not exclude the use of maquettes to develop ideas.

Dowel: a wooden peg or metal rod used to create a strong joint between two parts of a structure.

Earth pigments: naturally occurring iron-oxide *pigments* varying in colour between red, yellow, orange and brown, usually only of moderate intensity. The class includes ochre, sienna and umber.

Enzyme: a catalyst or reaction promoter for biochemical reactions. Enzymes have recently been introduced into conservation for cleaning painted surfaces.

Epoxy resin: a synthetic *resin* used as an adhesive or gap-filler which *cures* by chemical reaction, rather than through loss of *solvent*.

Ferrous metal: a metal containing iron.

Fibreglass: a strong composite material of *resin* and *glass fibres*.

Fill: any substance used in conservation treatments to fill voids in original material.

Filler: an inert material used with *resins* to increase bulk, viscosity, opacity or strength.

Flux: a paste, liquid or powder that assists the flow of hot solder when joining metals together.

Fruitwood: a general term used for wood from any fruit-bearing tree.

Gelatine: a flexible *mould* material derived from animal bones, but suitable only for *plaster of Paris* or wax casting. The shelf life of the mould is very short; it is only a matter of days before this organic material shrinks, dries and cracks. *Gelatine* was largely replaced by synthetic rubber-like materials in the mid-twentieth century.

Gesso: a white priming or ground used to prepare wooden panels or other supports for painting, gilding or other decorative processes.

Glass fibre: see *fibreglass*

Gouge: a sharp tool for hollowing out wood, the blade of which has a curved section and leaves a concave cut.

Graphite: a crystalline form of carbon. It has a metallic sheen and feels soft and greasy.

Grosgrain: commercial name of a strong corded silk fabric.

Heartwood: the dense interior part of a tree trunk yielding the hardest timber. It is generally separated from the outer wood (or **sapwood**) by sculptors to avoid shrinkage cracks.

Inpaint: to add paint to areas of loss in an original surface in order to restore design continuity. Often referred to as *retouching*.

Installation: a sculptural work that uses several elements including the display space.

Investment core: plaster-like material left inside a metal sculpture as a result of the casting process.

Iron oxide: common mineral found in many sedimentary rocks. See also *earth pigments*.

Lacquer: any kind of coating, natural *resin* or synthetic material that is dissolved in a *solvent* for application and dries, usually glossy, on the surface by evaporation of the *solvent*.

Lead carbonate: see *corrosion products* and *lead white*.

Lead white: basic lead carbonate, synthetically prepared for use as an opaque white *pigment*.

Limestone: a sedimentary stone largely composed of calcium carbonate. Limestones from Portland and Hornton are widely used by British sculptors and builders.

Linseed oil: oil extracted from flax seeds, which dries in air to form a tough, flexible film. It is mixed with *pigments* to form traditional oil paint.

Lipase: an *enzyme* able to decompose fats.

Lost wax (*cire perdue*): a casting process that involves making a wax version of a sculpture which is surrounded with plaster-like investment material and then heated. The wax melts to leave a cavity which is subsequently filled with molten metal. See pages 16–17.

Maquette: a preparatory model, usually in clay or wax, by which a sculptor establishes proportion, balance and composition on a small scale before it is made full-size in a more permanent and expensive material. A maquette is generally more finished and refined than a sketch model.

Marble: a term loosely applied to any stone capable of being polished. More accurately, a crystalline metamorphic rock composed primarily of calcium carbonate. White varieties of marble from Italy and Greece have been preferred by sculptors.

Microcrystalline wax: a stable synthetic wax widely used by conservators as a protective coating on metals.

Mortise and tenon: a joint between two pieces of wood where a projecting tongue (tenon) of one piece fits the corresponding cut-out (mortise) in the other.

Mother mould: a stiff outer *mould* that supports the numerous sections of a piece mould or floppy flexible rubber mould.

Mould: the negative impression of a sculpture into which material, e.g. *plaster*, *bronze* or *resin*, is poured to make a *cast* positive version of the original.

Nylon: a synthetic fibre first produced commercially in the US in 1938.

Ochre: see *earth pigments*.

Oxidation: a common chemical reaction between the surface of a material and oxygen.

Paint: a mixture of coloured *pigments* and a *binder*, e.g. *linseed oil*, which forms a solid film on drying.

Patina: a distinct surface layer on metal achieved by natural (*oxidation*) or artificial (chemical) means. It is usually regarded as desirable. Also refers to the altered surface of other materials, such as wood or stone, due to ageing.

Phenolic micro-balloons: conservation material used as a lightweight *filler* or *aggregate* with synthetic *resins*.

Piercing saw: a hand tool with a very thin cutting blade.

Pigment: small coloured particles that are combined with a *binder* and a medium to form paint.

Pitcher chisel: a flat chisel used for the preliminary blocking-out of stone.

Plaster of Paris: a fine white powder (calcium sulphate hemihydrate) which, when mixed with water, forms fully hydrated calcium sulphate, a white solid. Widely used by sculptors for *moulds* and preliminary *casts*.

Plasticene (UK), **Plastilene** (US), **Plastilina** (Spain): trade name of a malleable mixture of clay, wax and oil widely used by sculptors for sketch models and *maquettes*. See page 120.

Point chisel: also called a punch, used chiefly for the rough dressing of stone. Handled gently it can gradually reduce the surface, giving it an overall crumbly or pulverised appearance.

Polyester resin: a synthetic *resin* often used as a *binder* with glass fibres.

Polyethylene (polythene), **Polypropylene**, **Polystyrene**: ubiquitous plastic materials, known as polymers, found in many manufactured products.

Polyfilla: UK commercial gap – filler containing gypsum plaster and other additives

Poultice: a damp pack applied to a surface to mobilise dirt and other substances. The contaminants are drawn into the pack as it dries.

Prussian Blue: semi-translucent, intensely coloured, slightly greenish-blue *pigment*, ferric ferrocyanide.

Rasp: a coarse file, used for shaping and smoothing *plaster*, wood, ivory, stone etc.

Resin: a substance from either a plant or insect secretion, or from industrial manufacture, which is usually soluble in organic *solvents* but not in water.

Retouch: see *inpaint*.

Riffler file: a tool that is usually double-edged and curved, used for areas that straight files cannot reach.

Risers: ventilation passages that allow hot air to escape from the *mould* in metal casting.

Roman joint: a sleeve and socket joint that connects two cast pieces of sculpture.

Runner: a routeway by which molten metal is fed through the investment into the *mould* in metal casting.

Rust: familiar corrosion on ferrous metals caused by *oxidation*.

Sand casting: a metal casting process that involves making an impression of a sculpture in compacted sand. It is usually used for large smooth shapes but is also capable of reproducing fine detail. See page 29.

Sapwood: the living portion of a tree, between the bark and the heartwood.

Shellac: natural *resin* (from the secretion of lac insects) used as a *binder* for *pigments* as well as a sealer on *plaster moulds*.

Silica gel: a highly porous moisture-sensitive form of silica which can be used to control the relative humidity of the air surrounding an object.

Silicone rubber: cold-setting synthetic *resin* commonly used for *mould* making.

Silt: fine-grained water-borne sediment.

Silver plate: a very thin layer of silver deposited on the surface of another metal, often a *copper alloy*.

Solder: an *alloy* used to join metals of higher melting temperatures. Commonly made of lead and tin.

Solvent: any material, usually liquid, that can dissolve another material.

Stainless steels: iron-chromium *alloys*, widely used for their corrosion resistance and non-rusting quality.

Steel: an *alloy* of iron and carbon.

Tenon: see *mortise and tenon*.

Triptych: a work having three related images side by side.

Varnish: a general term for a transparent *resin* coating, applied as a protective layer or to enhance the appearance of the surface underneath.

Vermilion: a brilliant red to orange *pigment* made from toxic mercuric sulphide.

Vinyl: a component of many synthetic plastics available commercially since the mid-twentieth century.

White spirit: a commercially available petroleum-based *solvent* which softens and dissolves waxes and other materials. Also known as naphtha.

CREDITS

The publishers have made every effort to trace all the relevant copyright holders and apologise for any omissions that may have been made.

Photographic Credits
Photographs have been provided by the Tate Gallery Photographic and Conservation Departments except where specified in the list below. Within the Photographic Department credit is due to the following photographers: Andrew Dunkley (fig.1); Ken Hickey (figs.102–12); David Lambert (figs.22, 52, 72, 113–14, 116, 122); Marcus Leith (figs.2, 119–20); Gill Selby (figs.5, 8, 12–14, 16, 19, 20–1, 26–7, 31, 33, 37–8, 43–6, 50, 59, 62, 65, 67–71, 74–6, 79–83, 91, 94, 101, 115).

fig.4 Photograph by Alfred Stieglitz, from the second issue of *The Blind Man*, published May 1917, by Marcel Duchamp, Beatrice Wood, and H.-P. Roché. Photograph courtesy The Museum of Modern Art, New York

fig.7 Tate Gallery Archive (photo: Sir Norman Reid)

fig.17 Paris, Musée d'Orsay

figs.24 & 49 Drawings by Stella Willcocks

fig.32 Courtesy of the National Portrait Gallery

figs.34 & 35 Reproduced from the *Royal Academy Pictures*, 1893 and 1899. Courtesy of the Royal Academy of Arts

fig.39 Philadelphia Museum of Art

figs.40 & 42 Photographs by Constantin Brancusi, Musée national d'art moderne/Centre de création industrielle, Centre George Pompidou, Paris

figs.60 & 61 Tate Gallery Archive

figs.74 & 75 Photographs by Erid Hesmerg.

fig.120 Photograph by Kiar Perov

Artists' Copyright Credits
Beuys © DACS, 1999

Brancusi © ADAGP, Paris, and DACS, London 1999

Duchamp © Succession Marcel Duchamp/ ADAGP, Paris, and DACS, London 1999

The works of Naum Gabo © Nina Williams

Barbara Hepworth © Barbara Hepworth Estate, Alan Bowness

The works illustrated on pages 63–71 are reproduced by permission of the Henry Moore Foundation

Index

Page references in **bold** indicate definitions in the Glossary

Page references in *italic* indicate definitions in Methods of Examination and Analysis